spinal of the original of the

A Coloring Experience

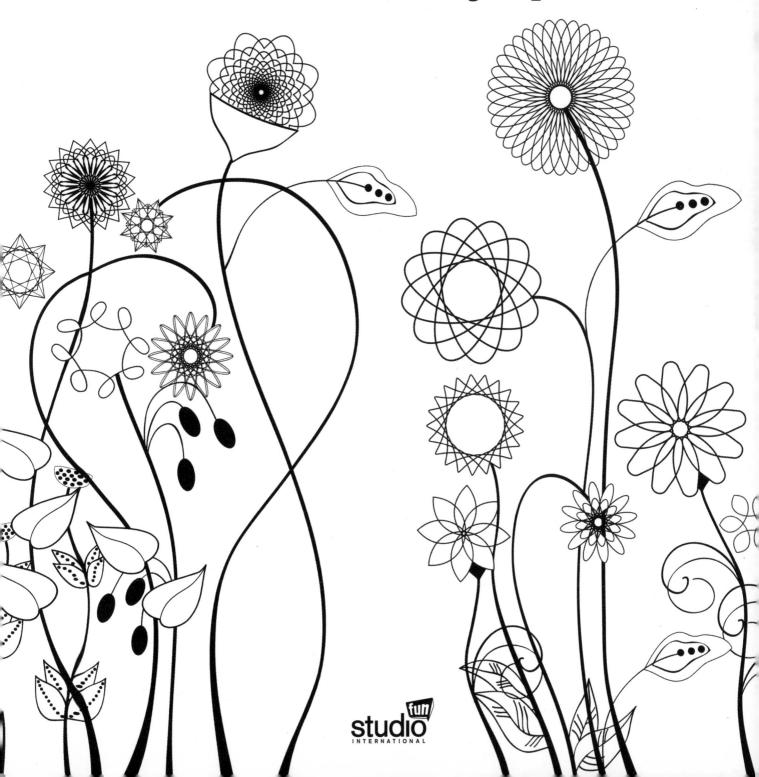

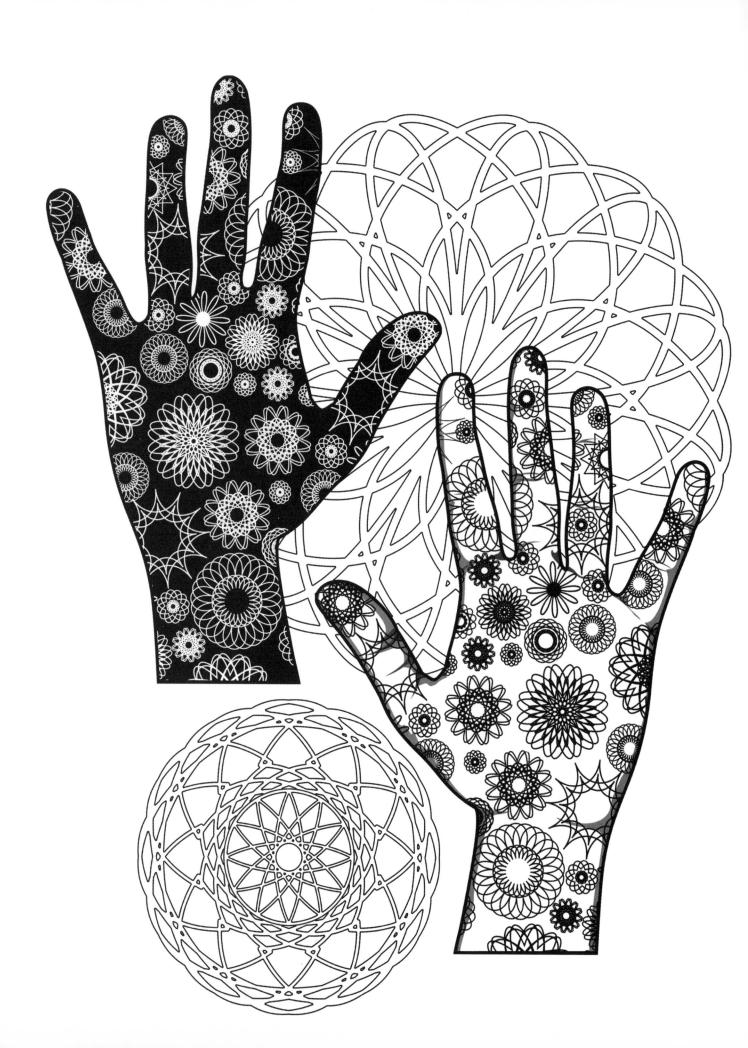

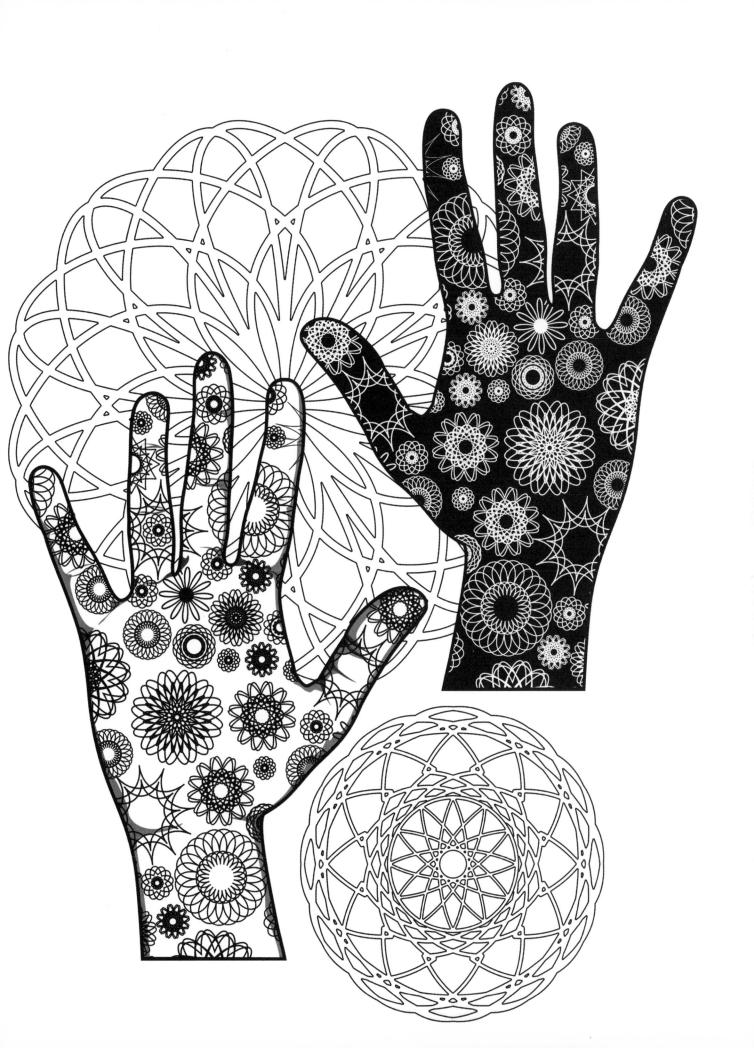

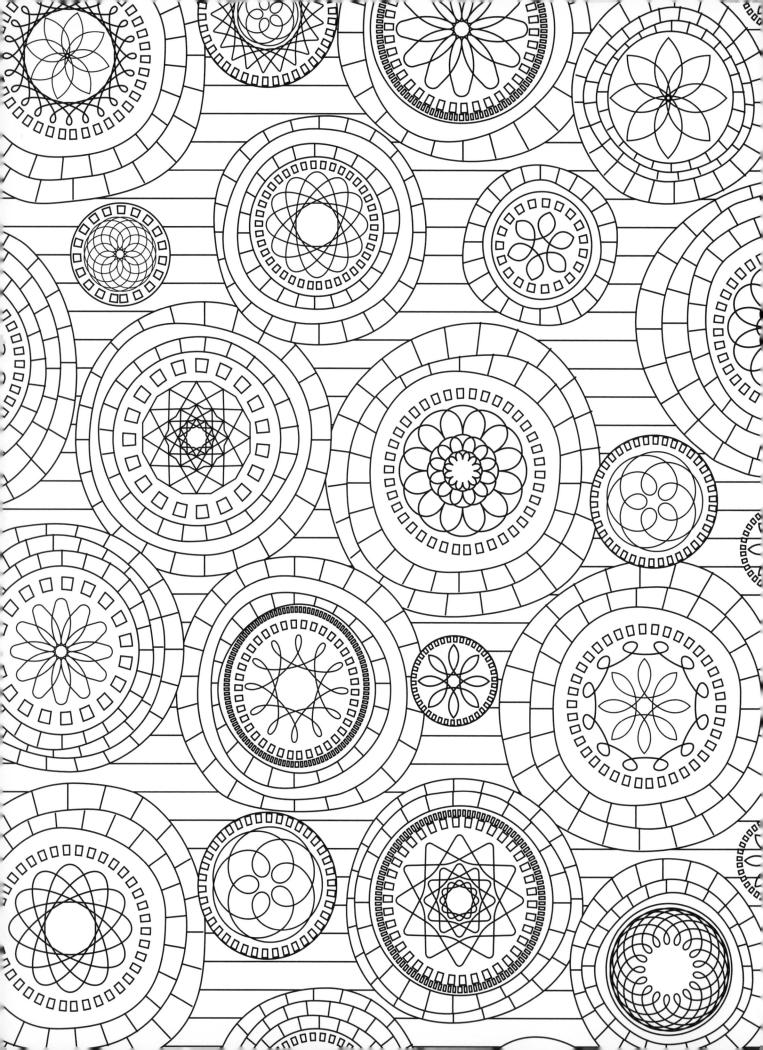

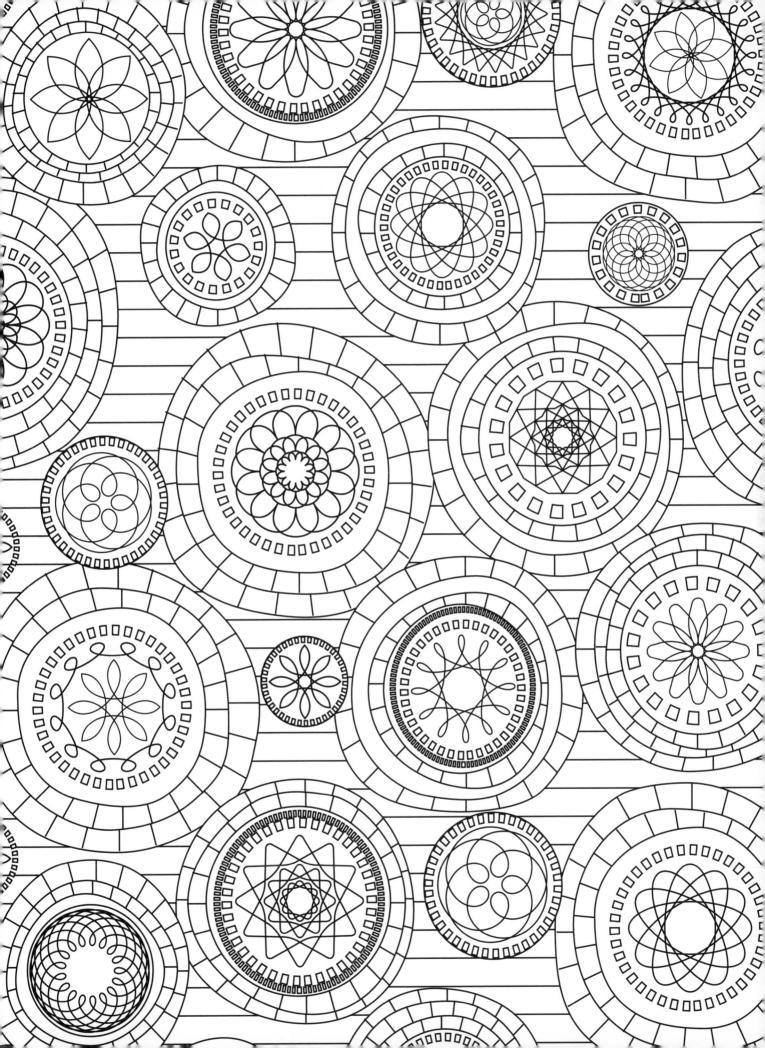

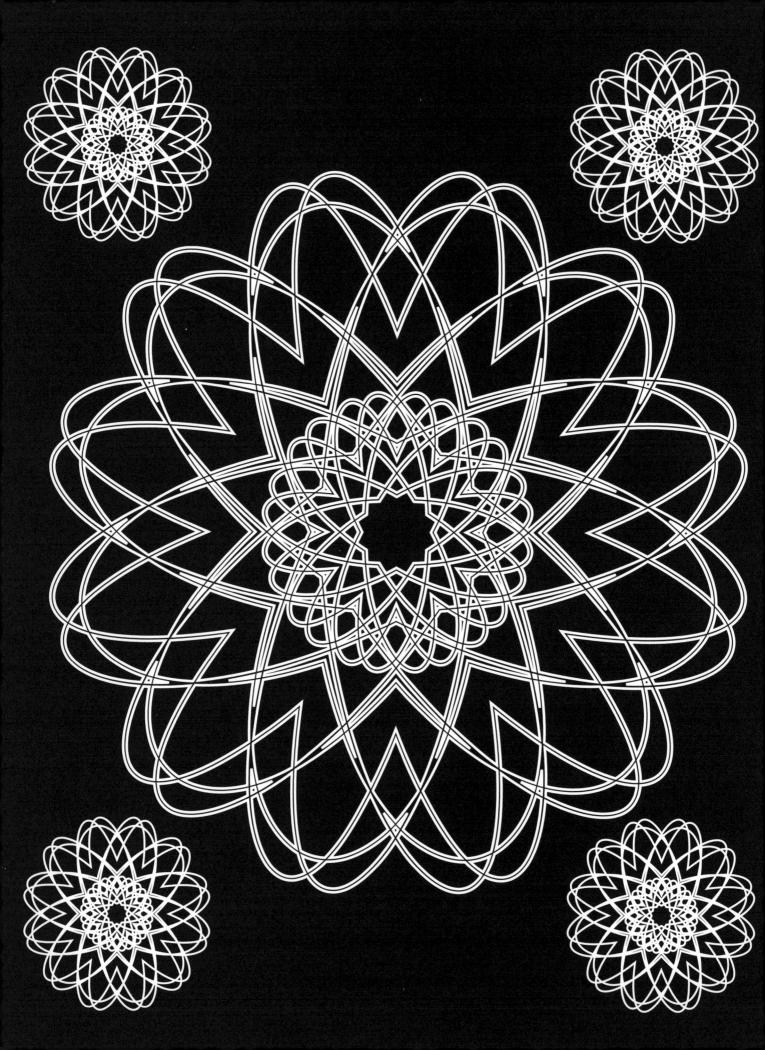

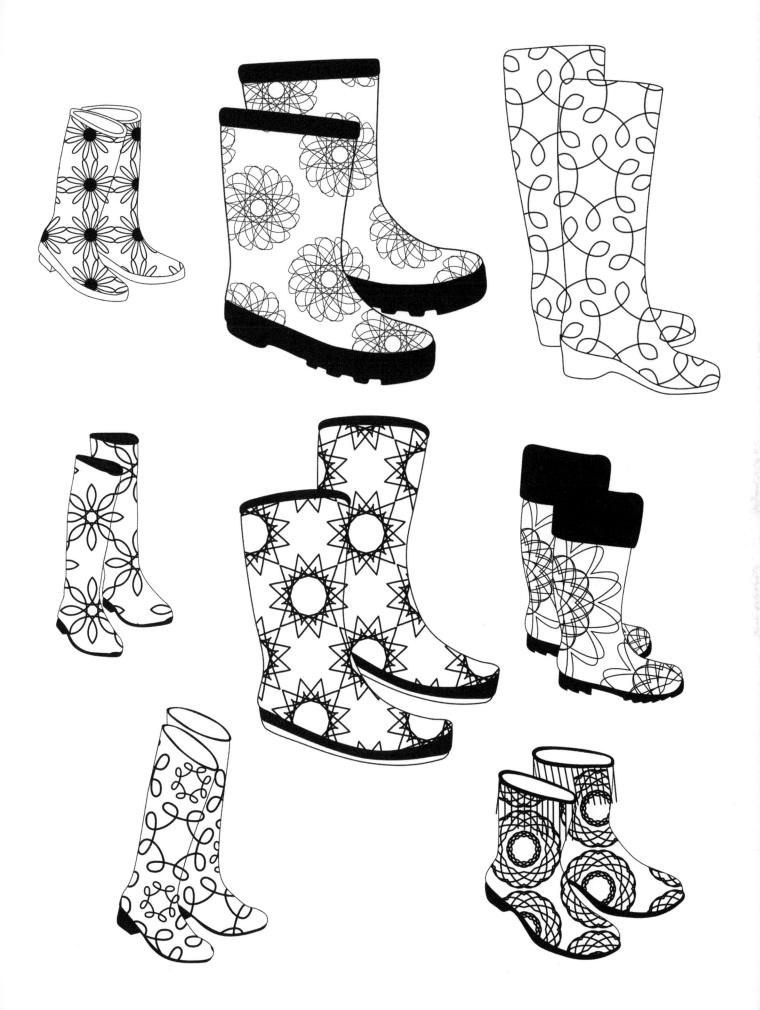

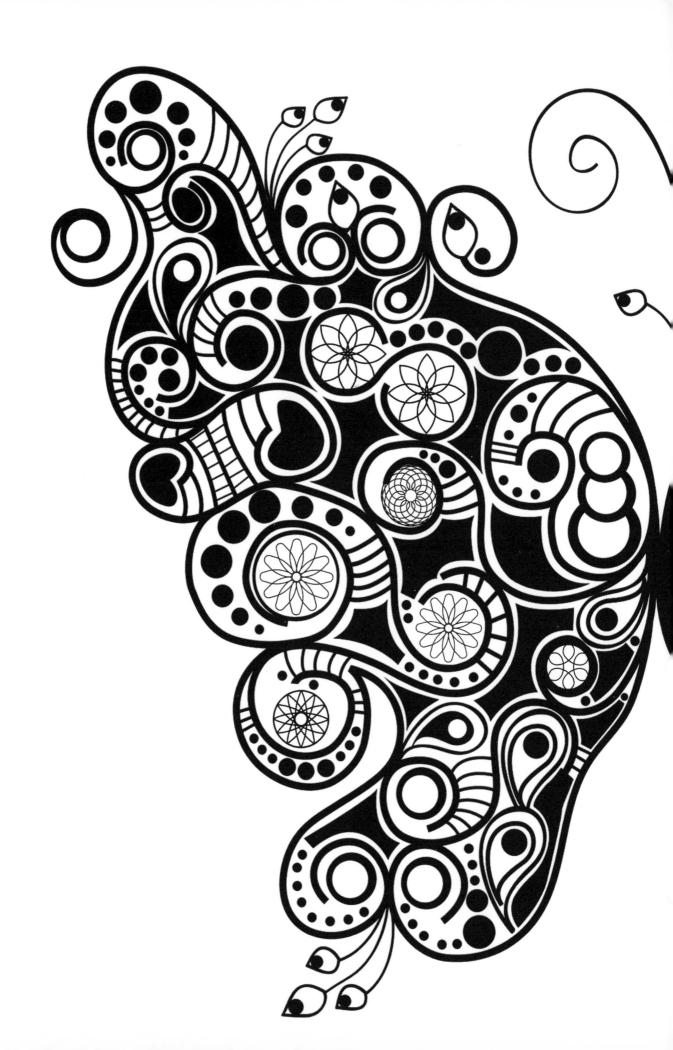

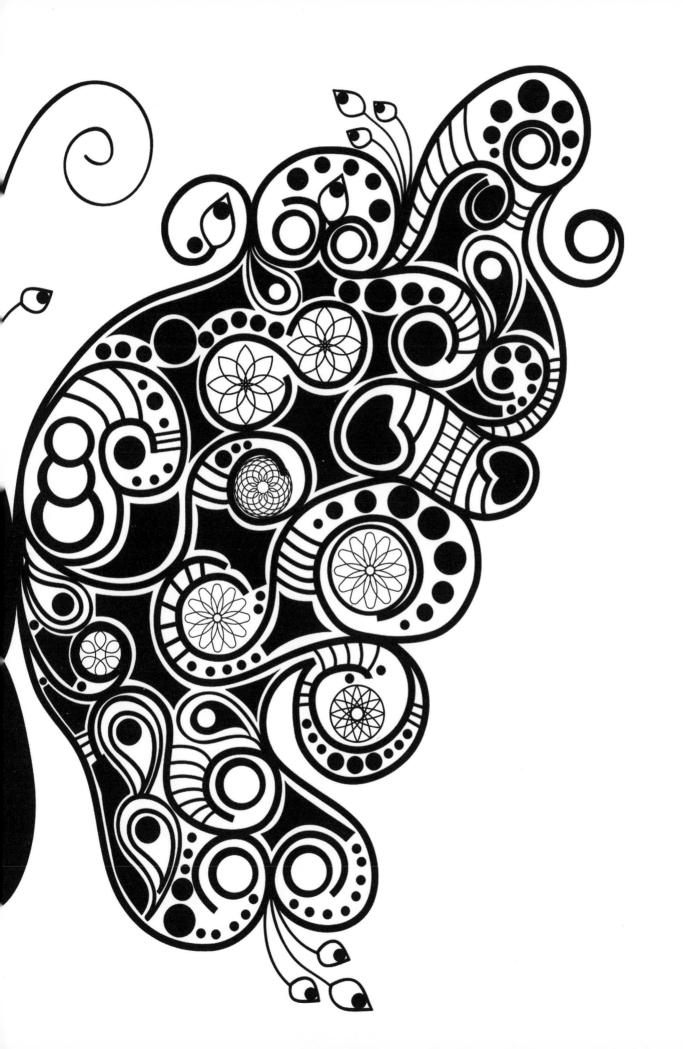

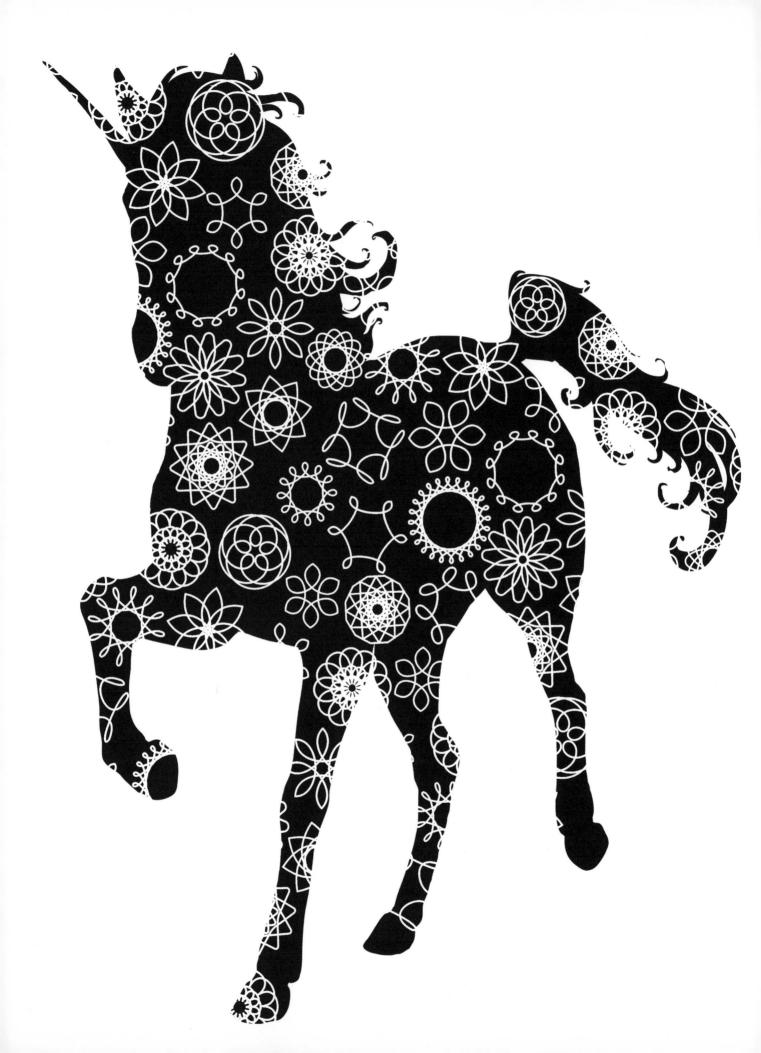

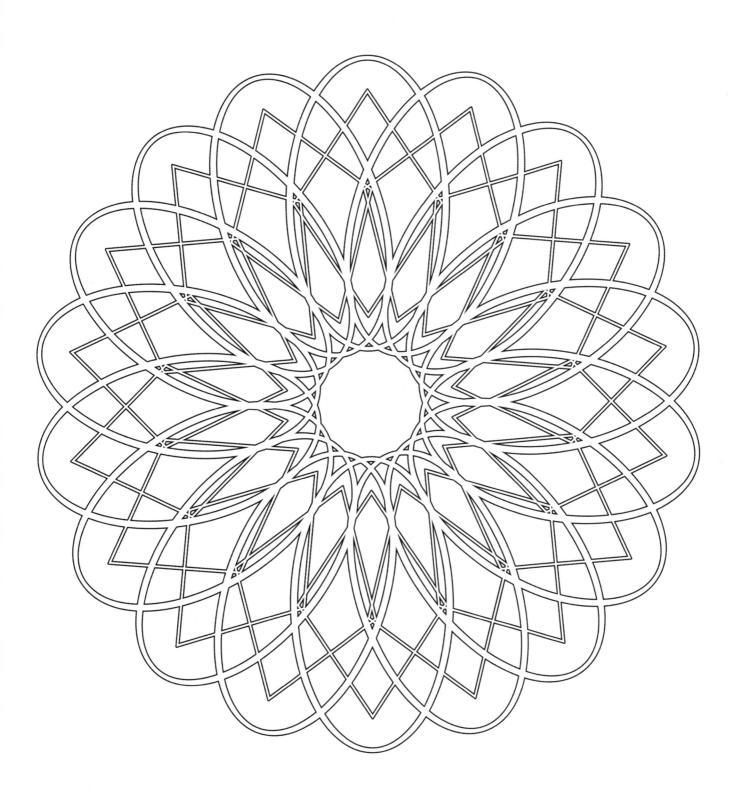

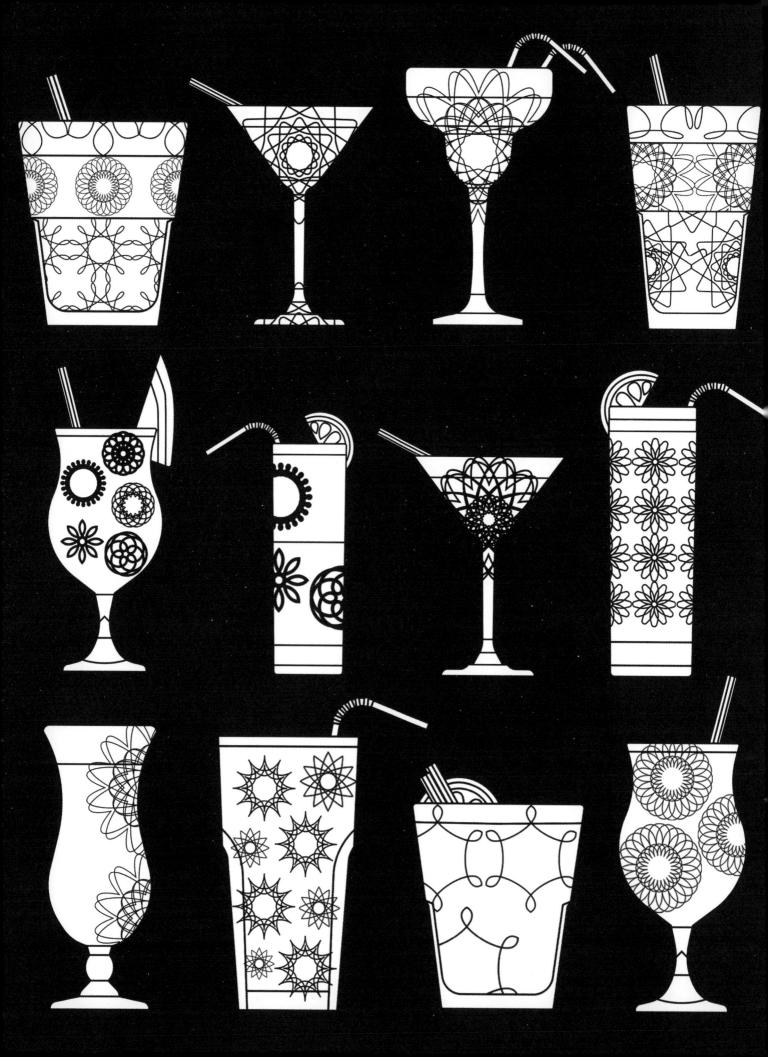

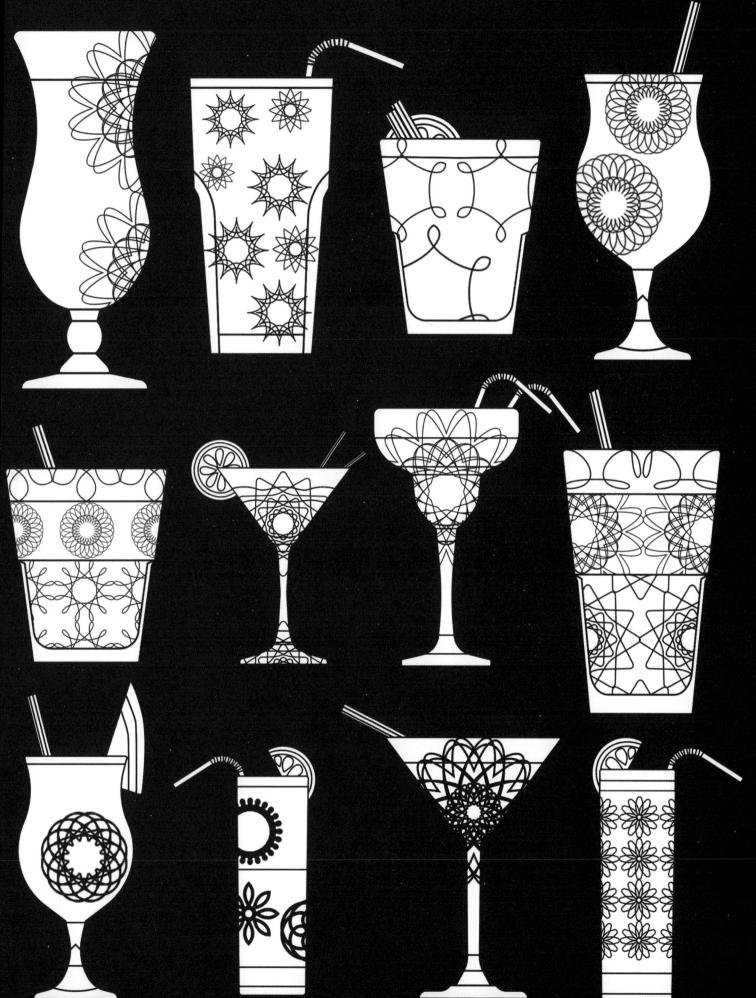

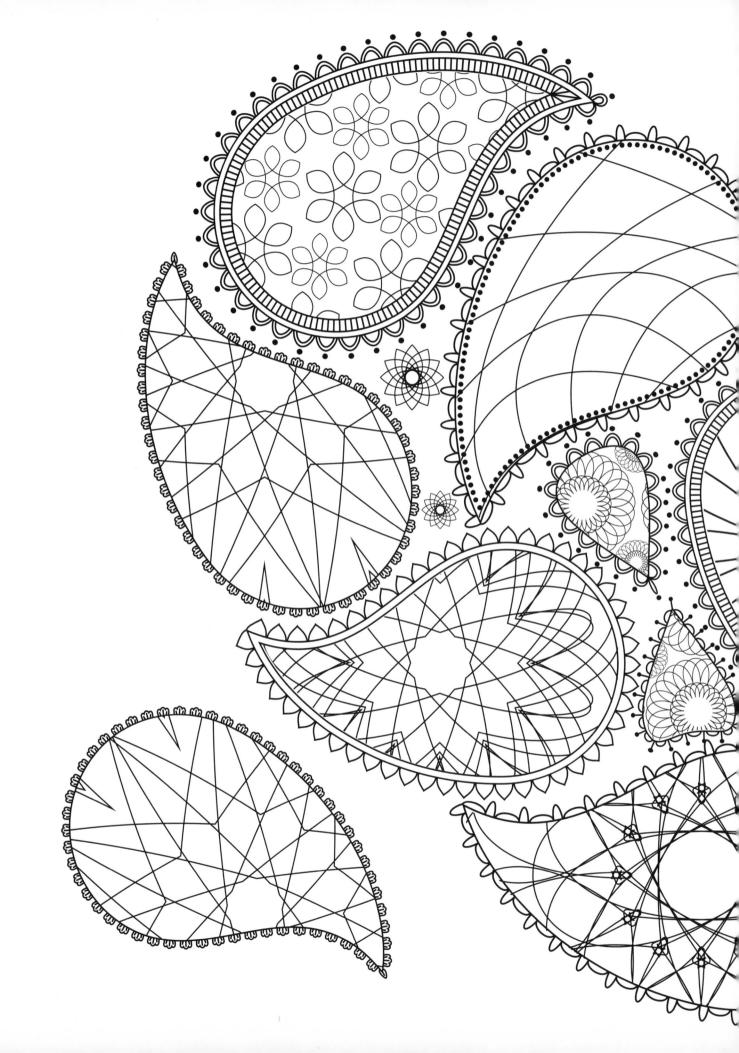

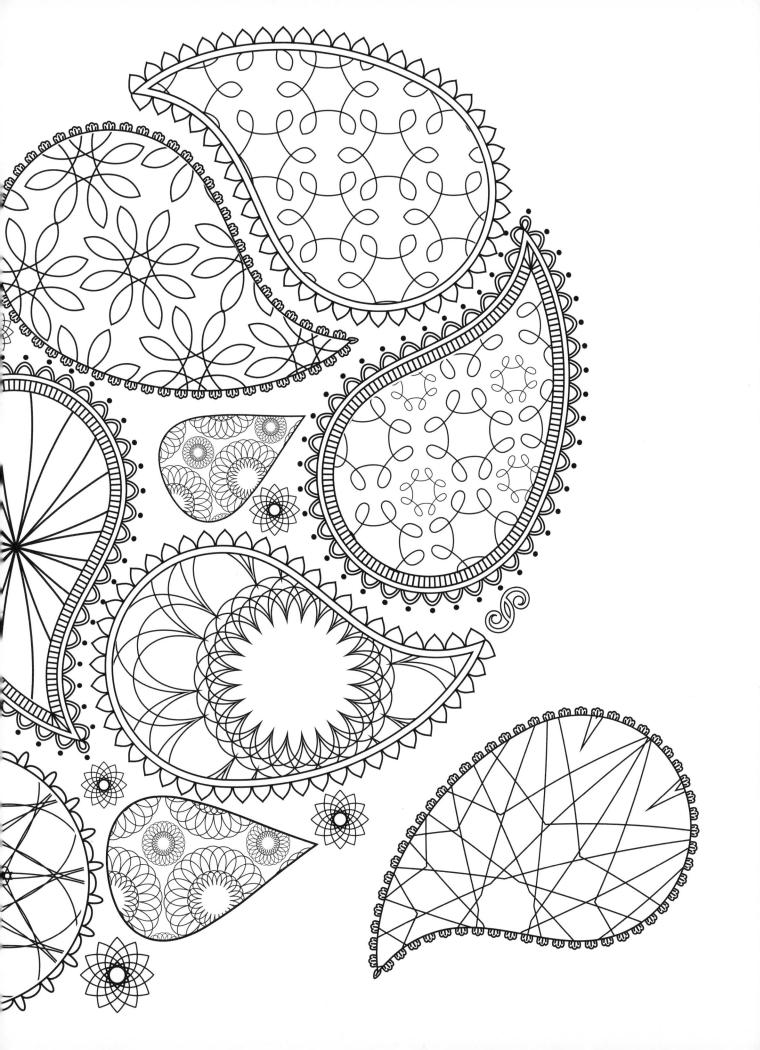

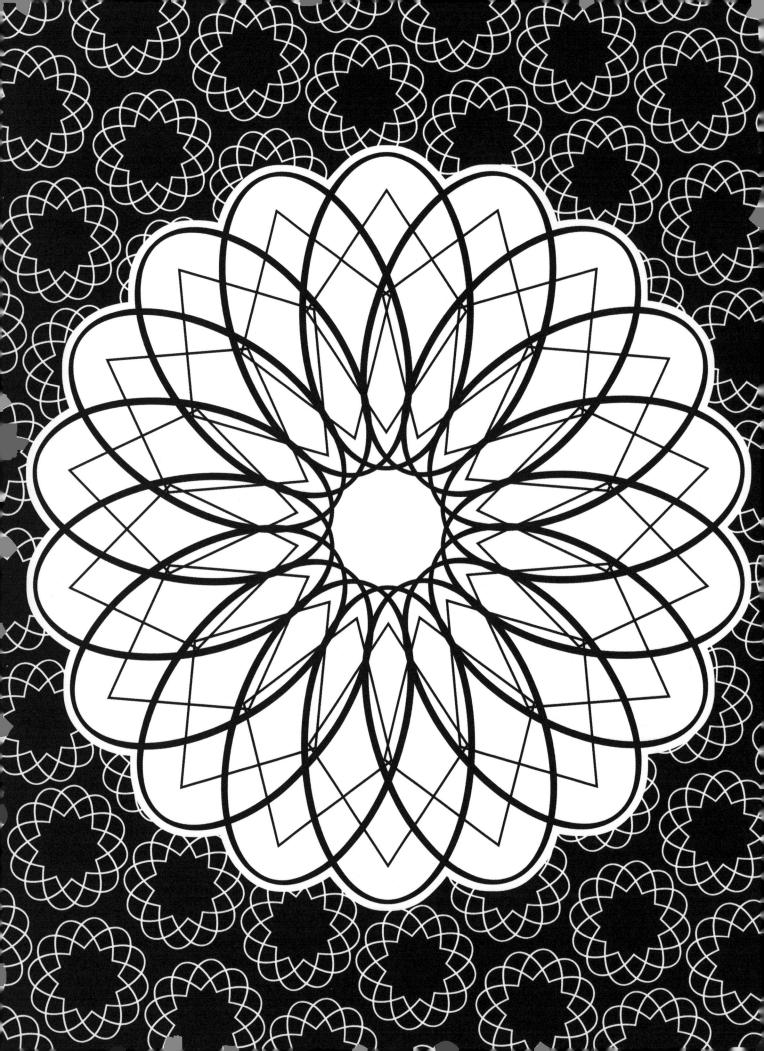

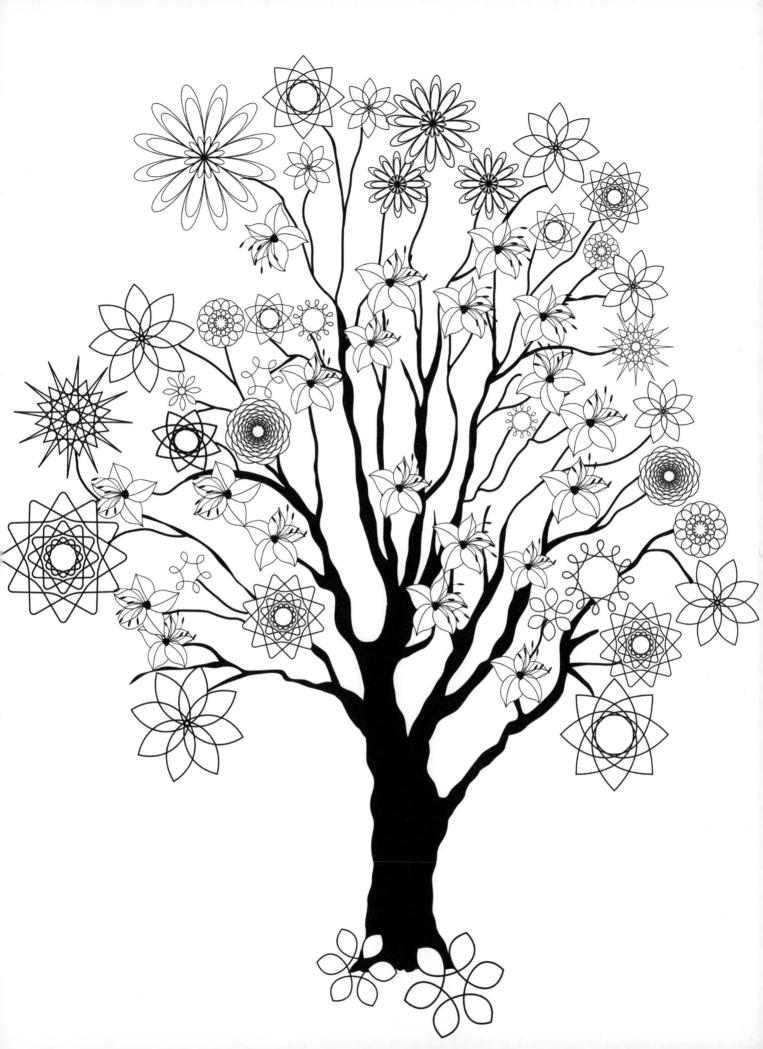

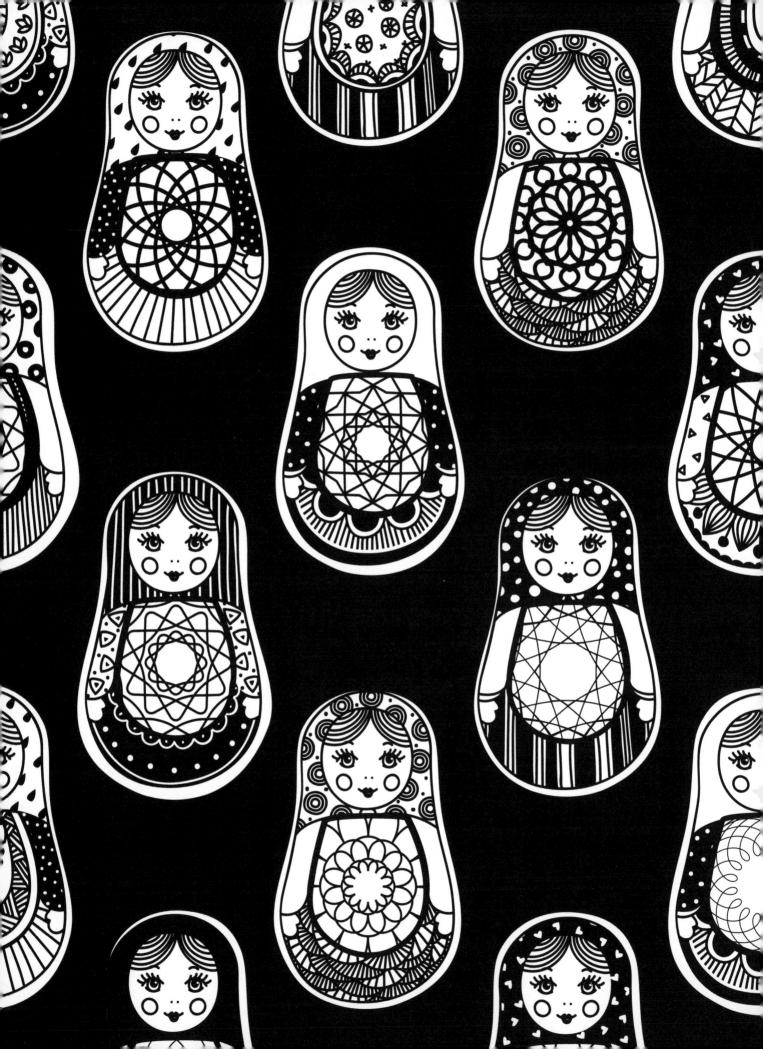

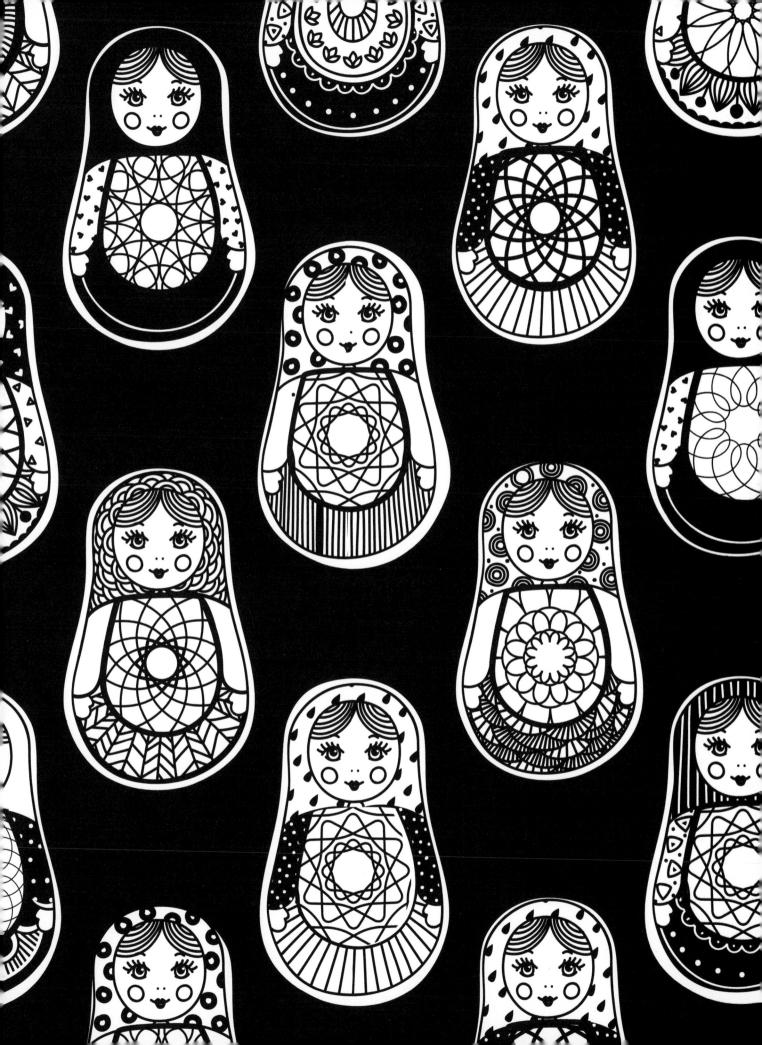

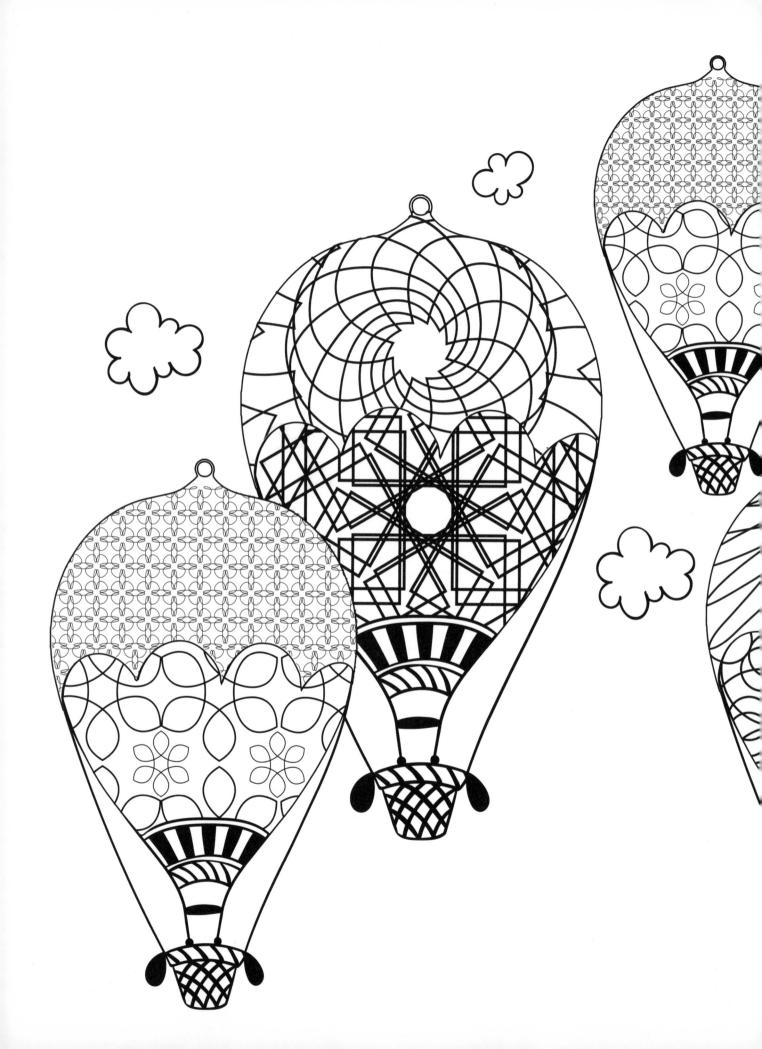

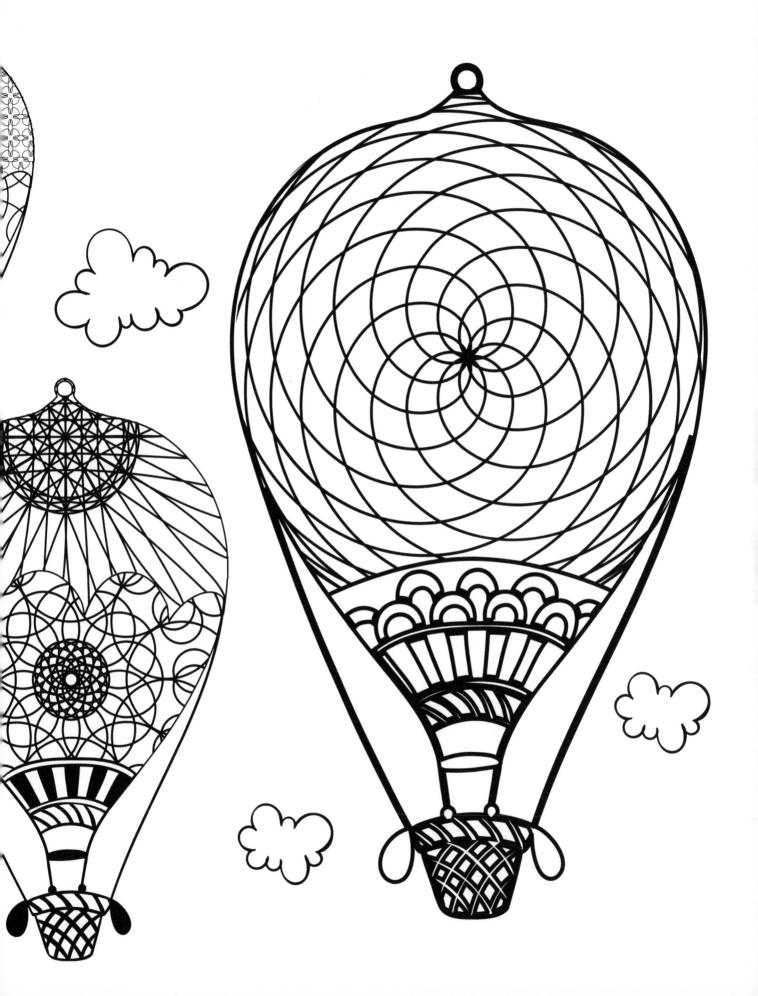

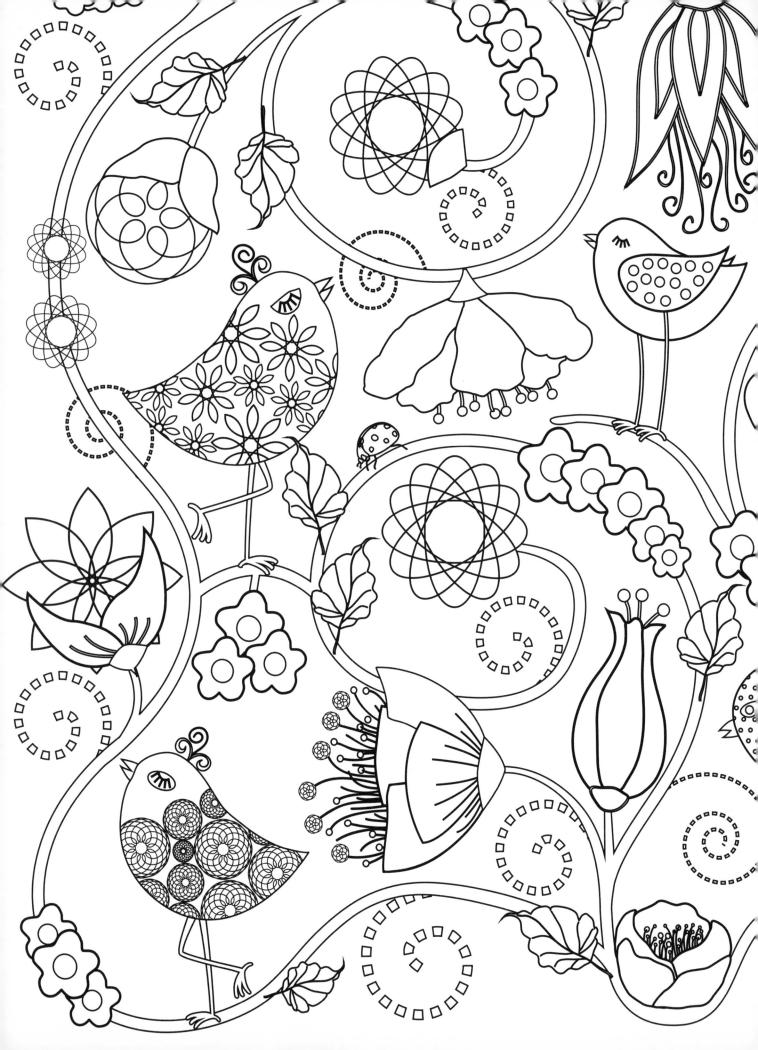

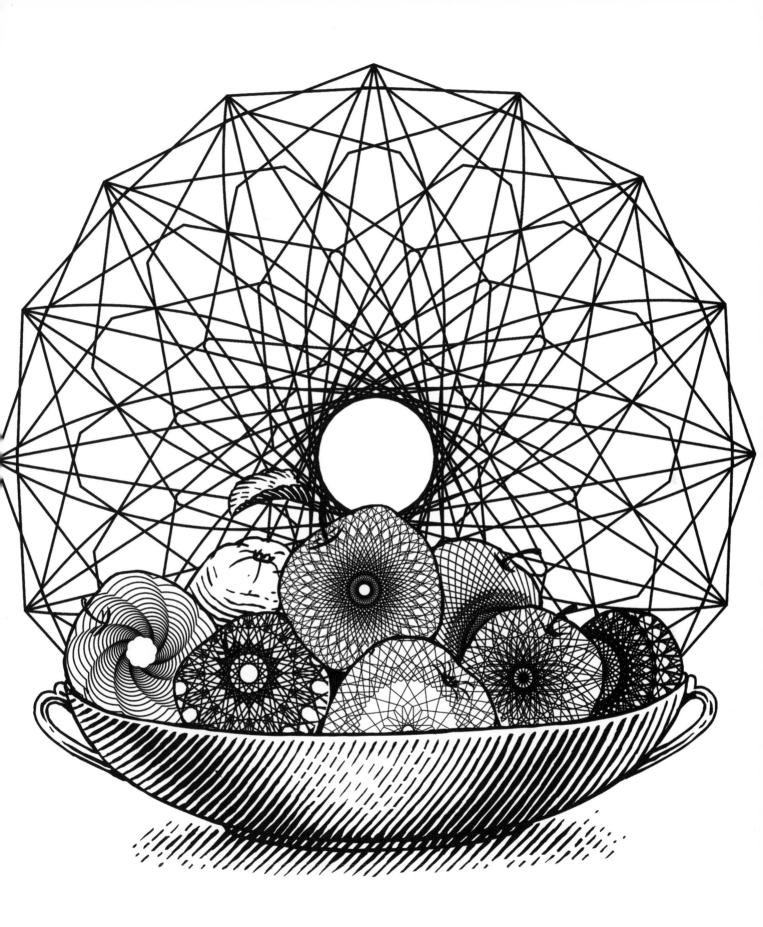

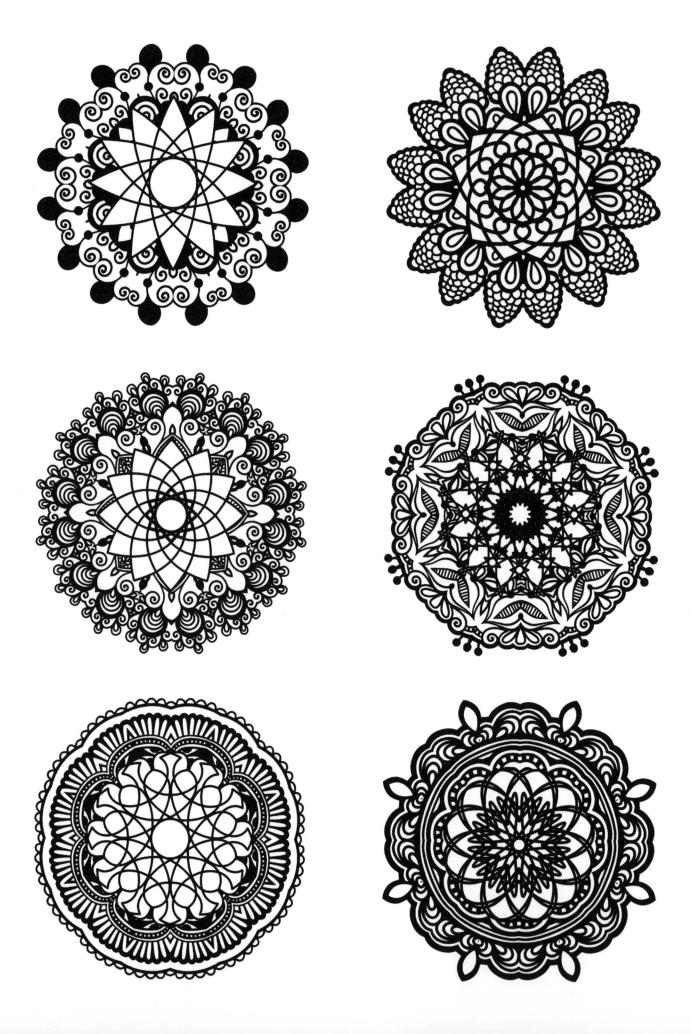

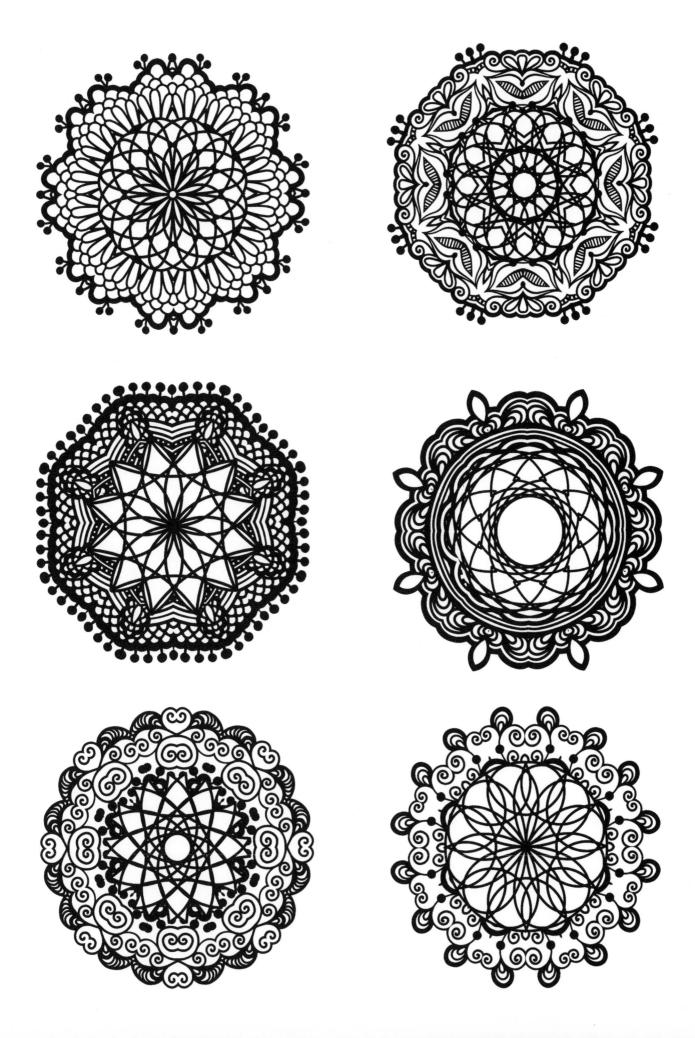

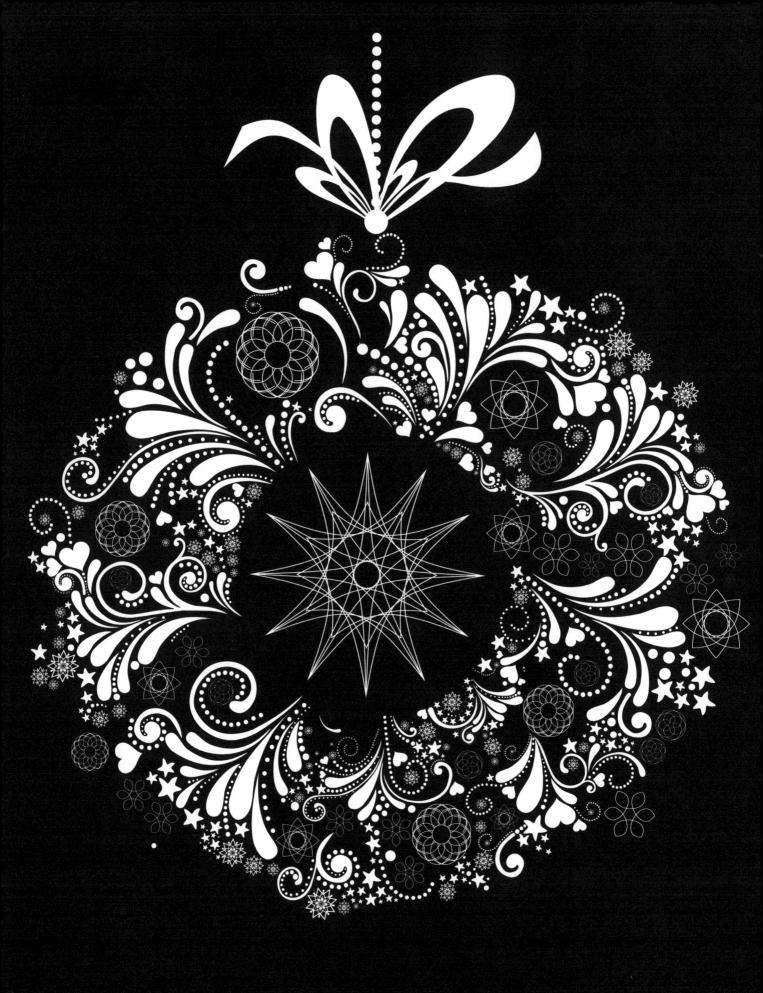

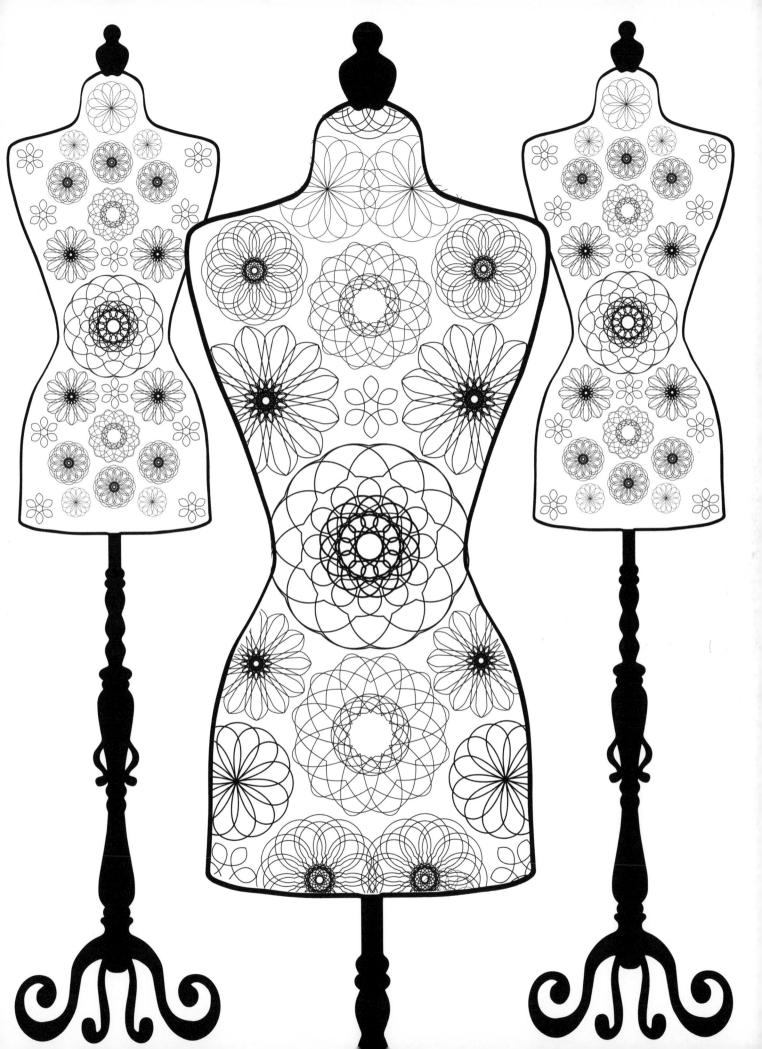

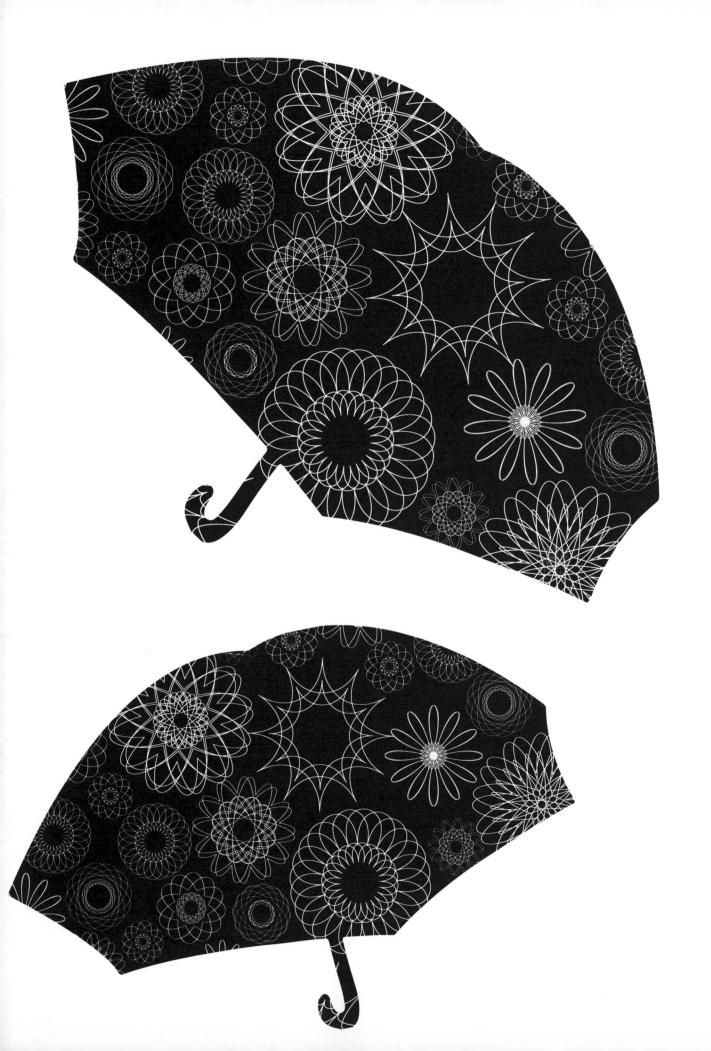

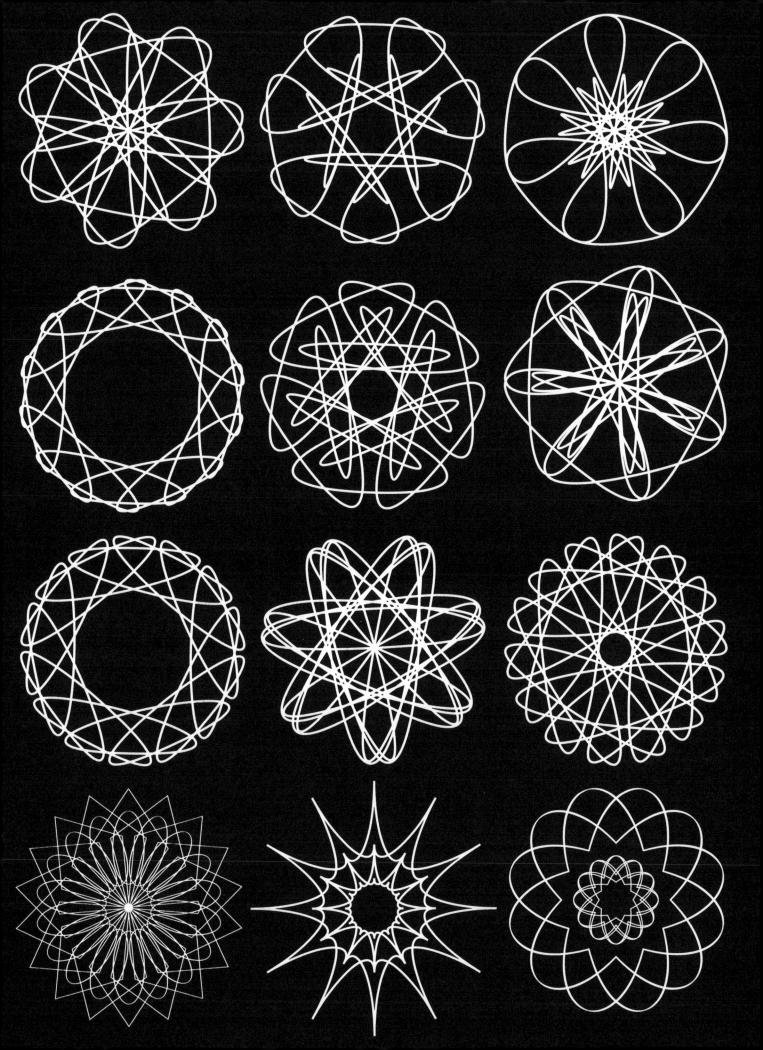

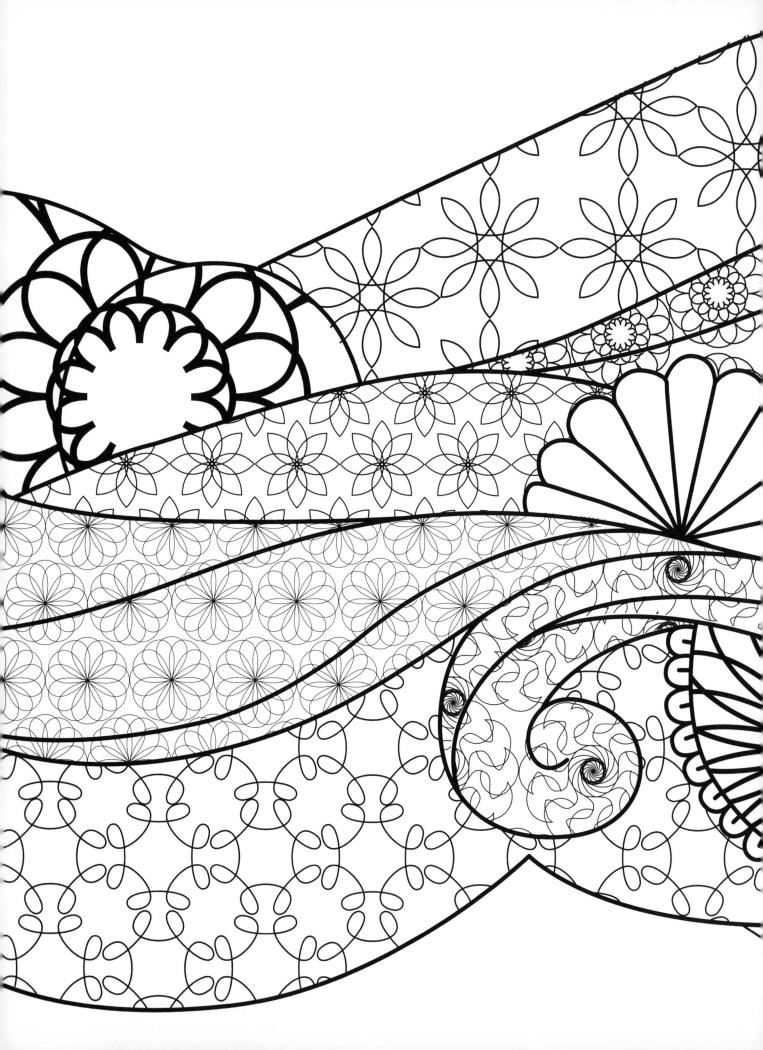

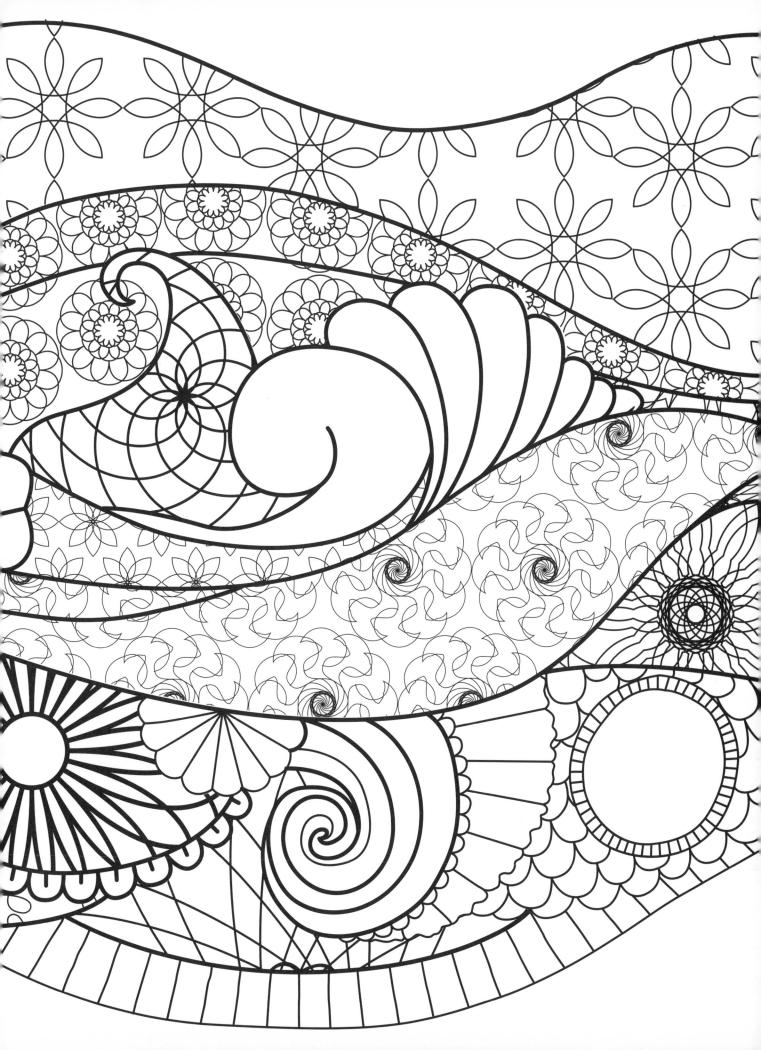

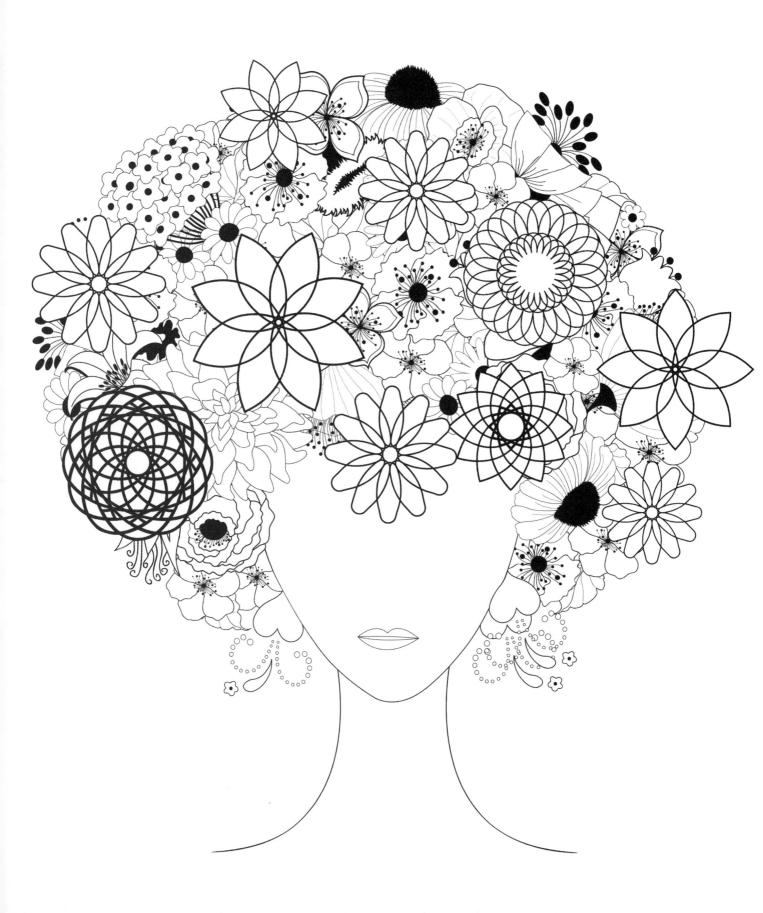

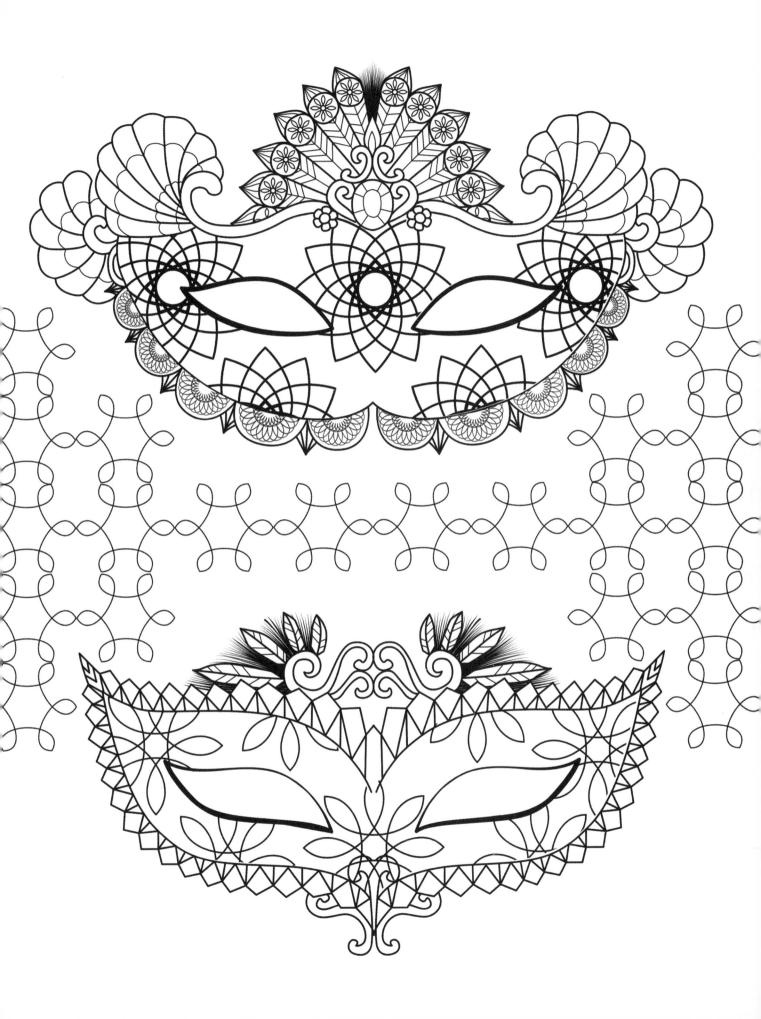

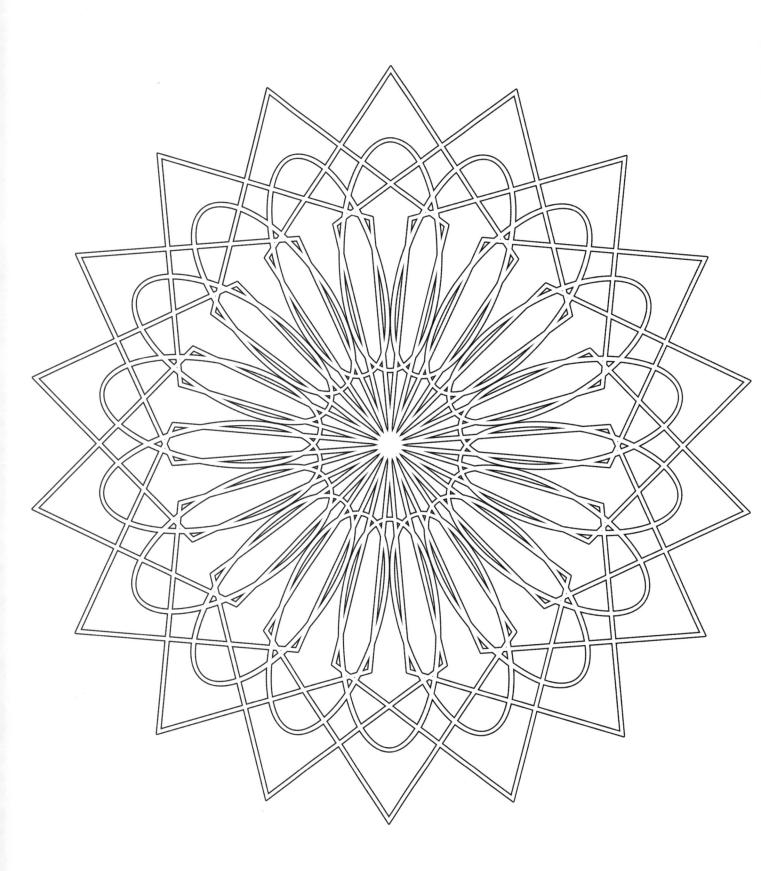

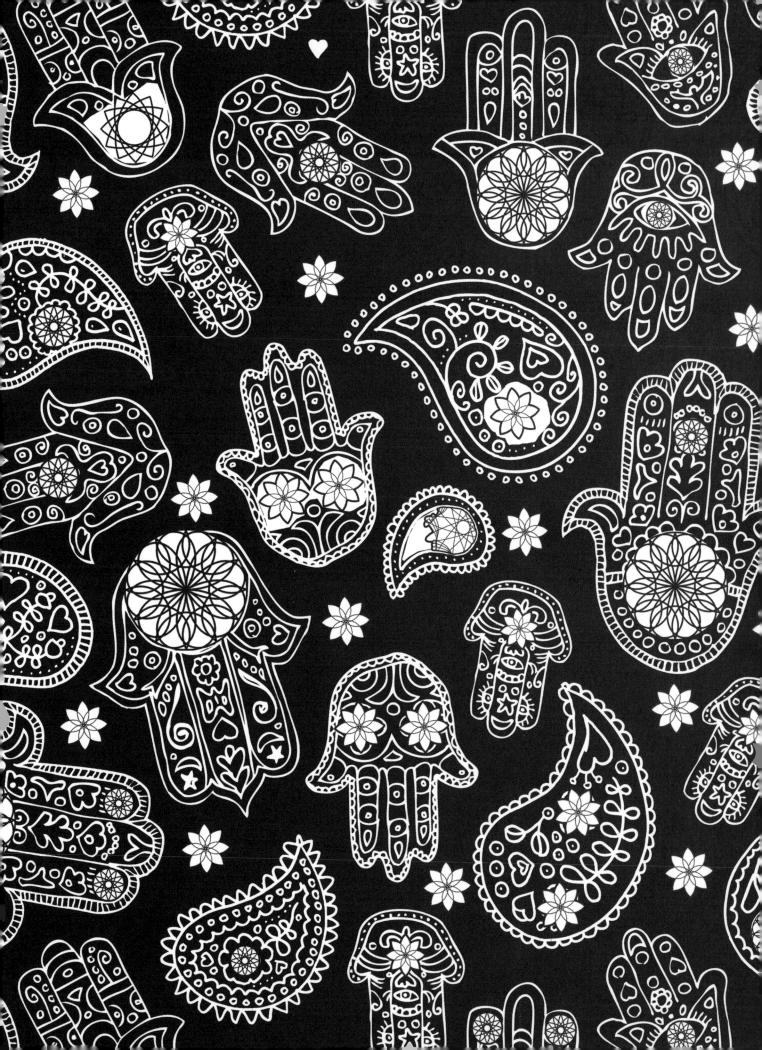

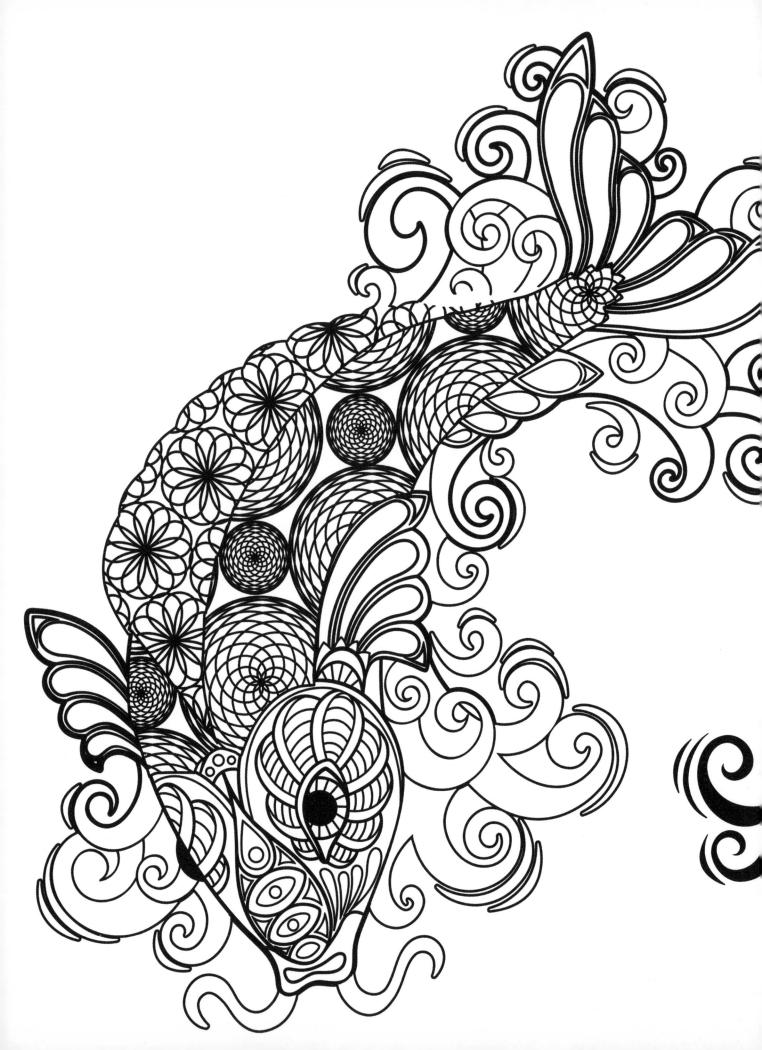

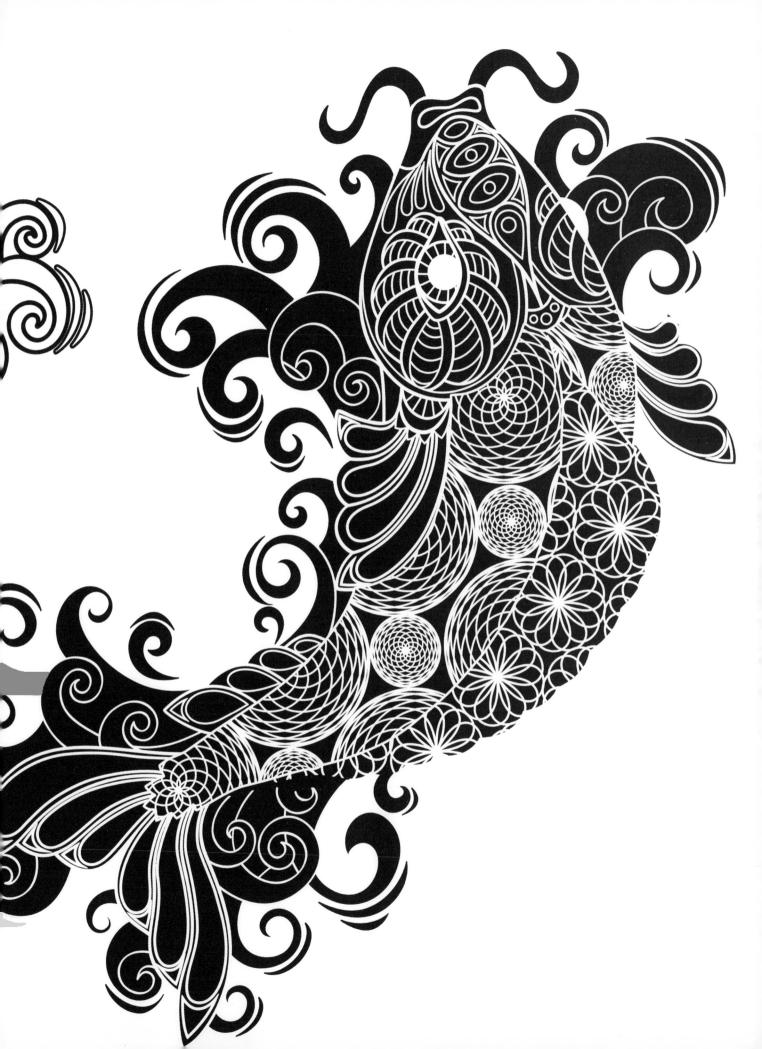

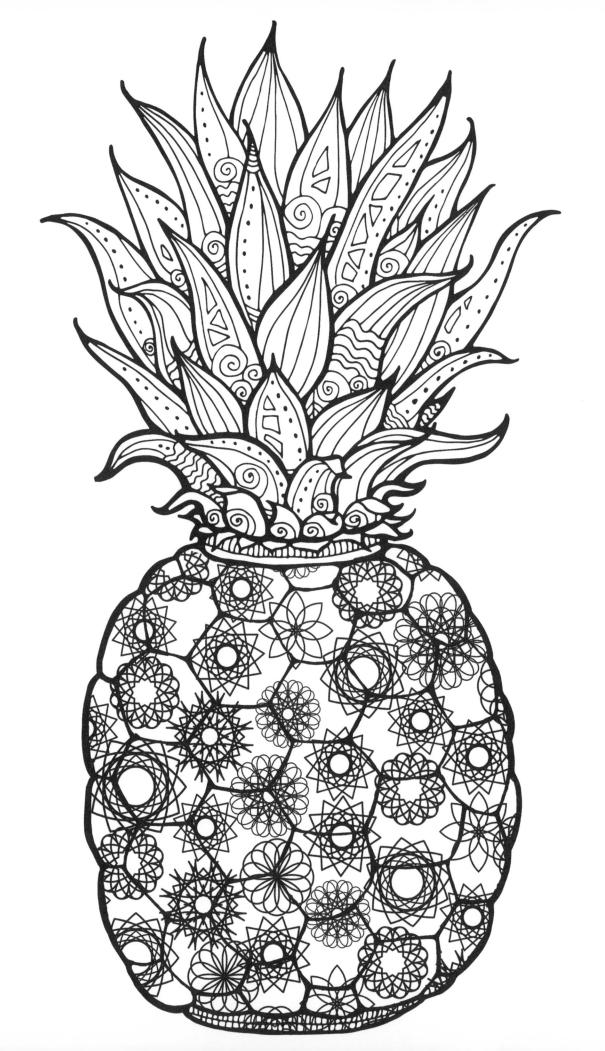

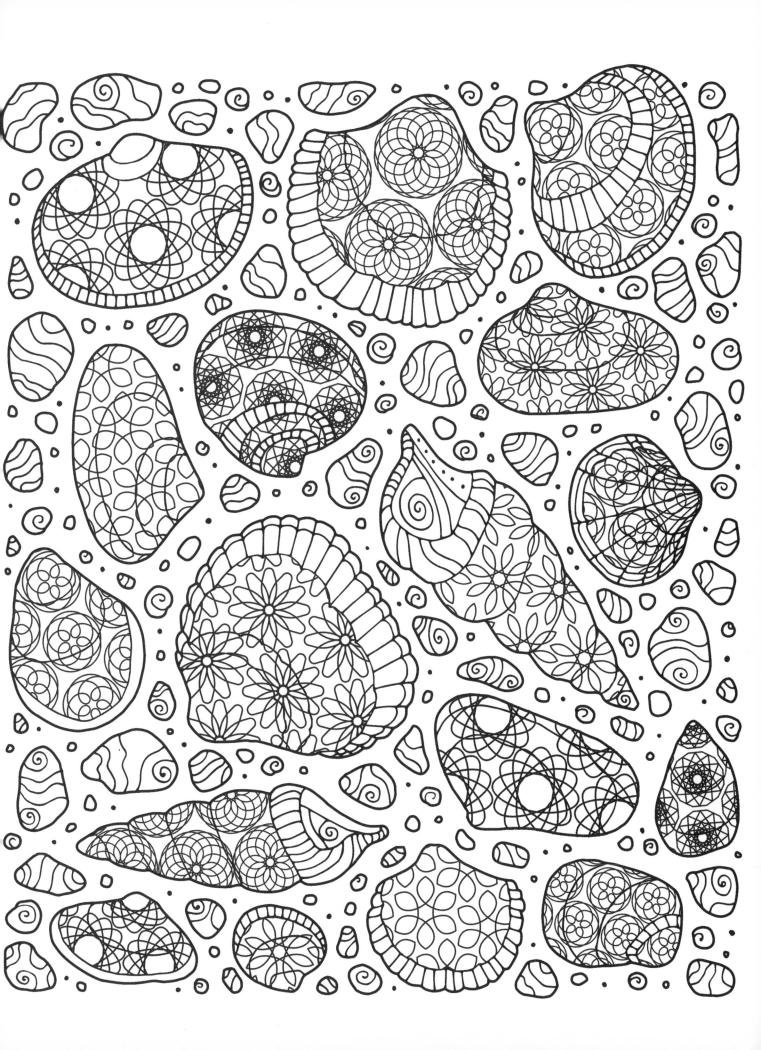

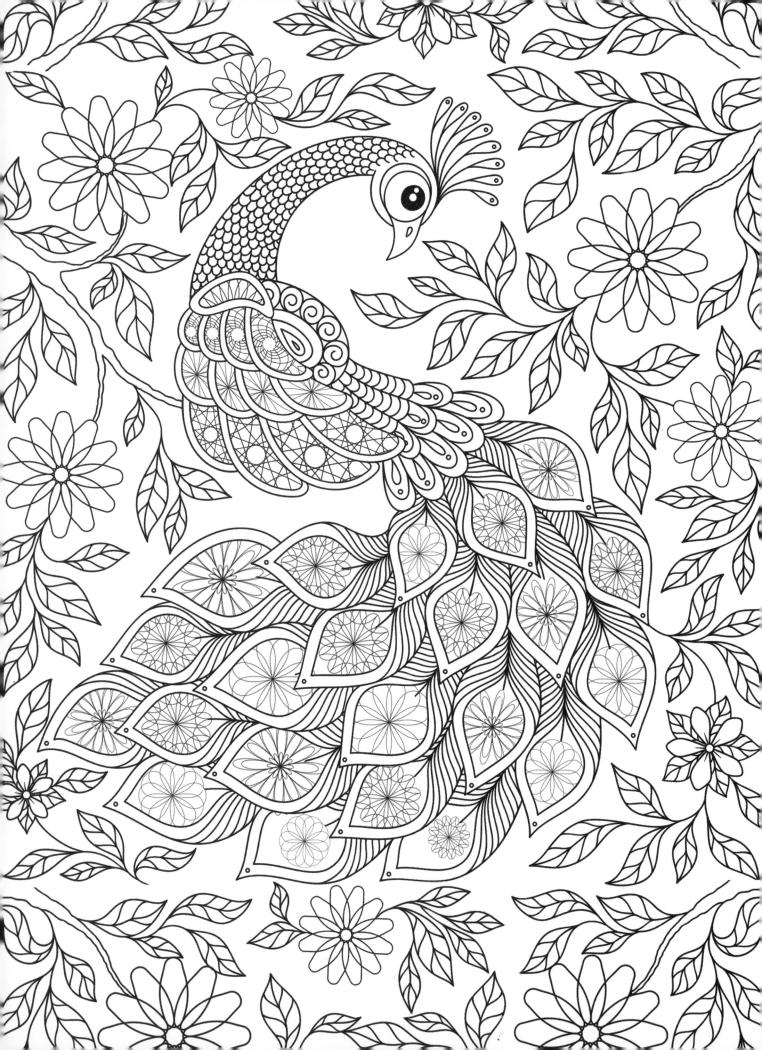

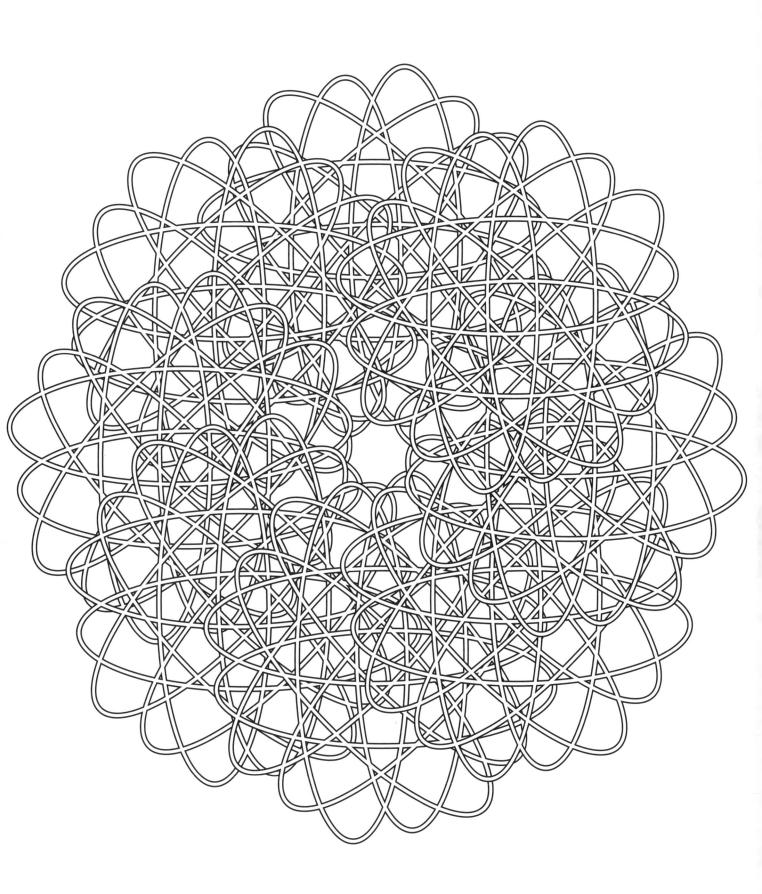

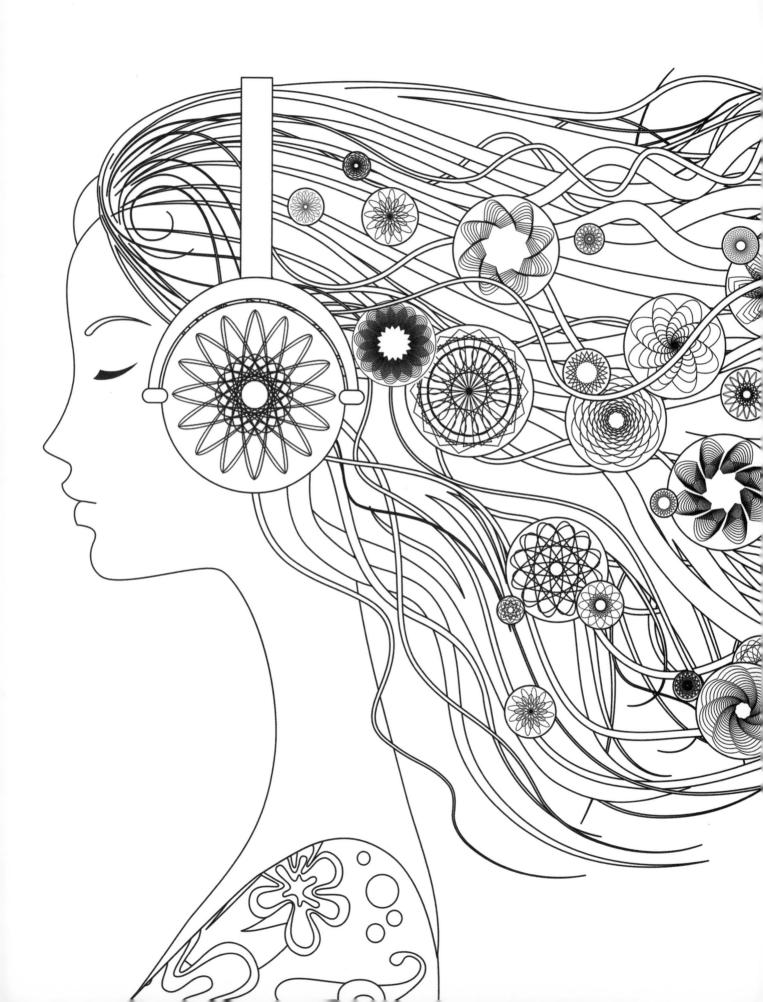

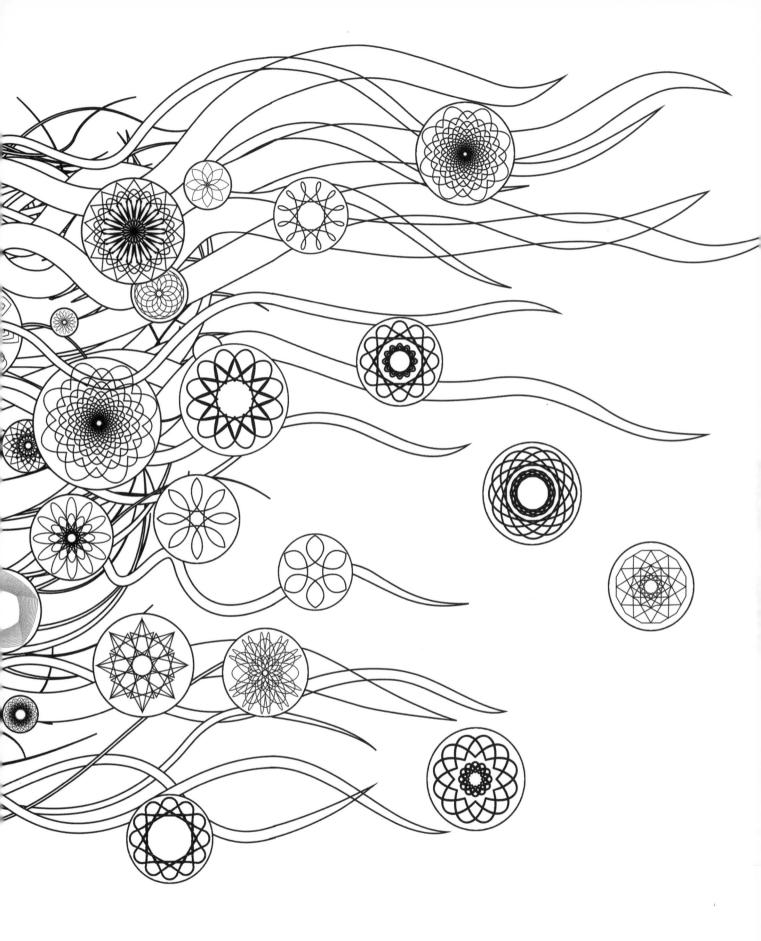

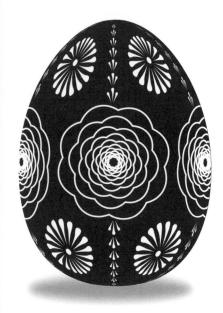

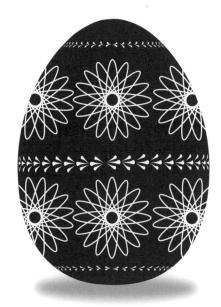

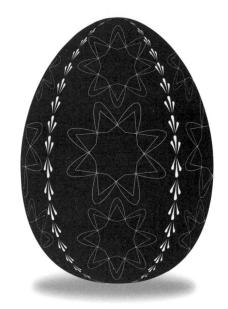

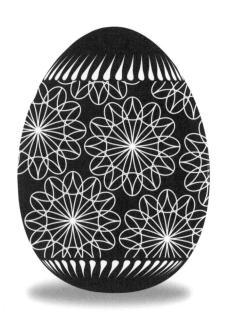

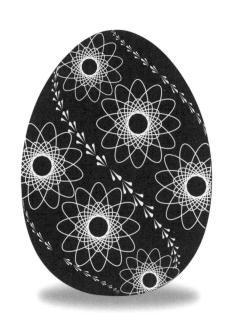

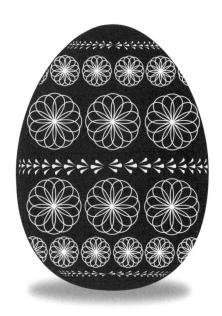

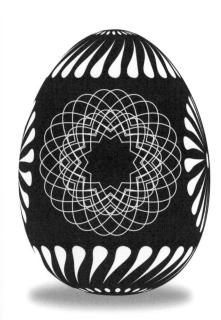

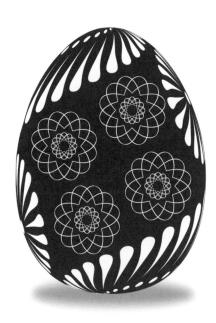

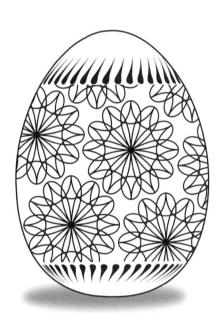

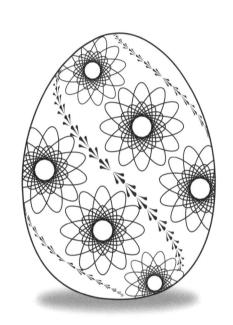

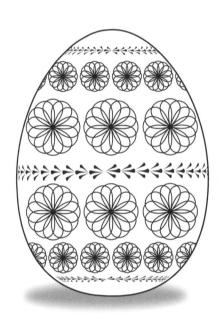

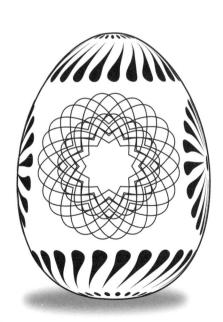

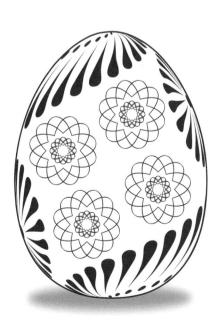

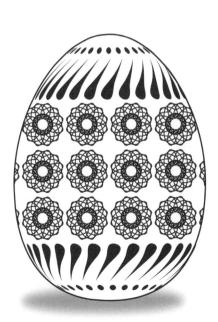

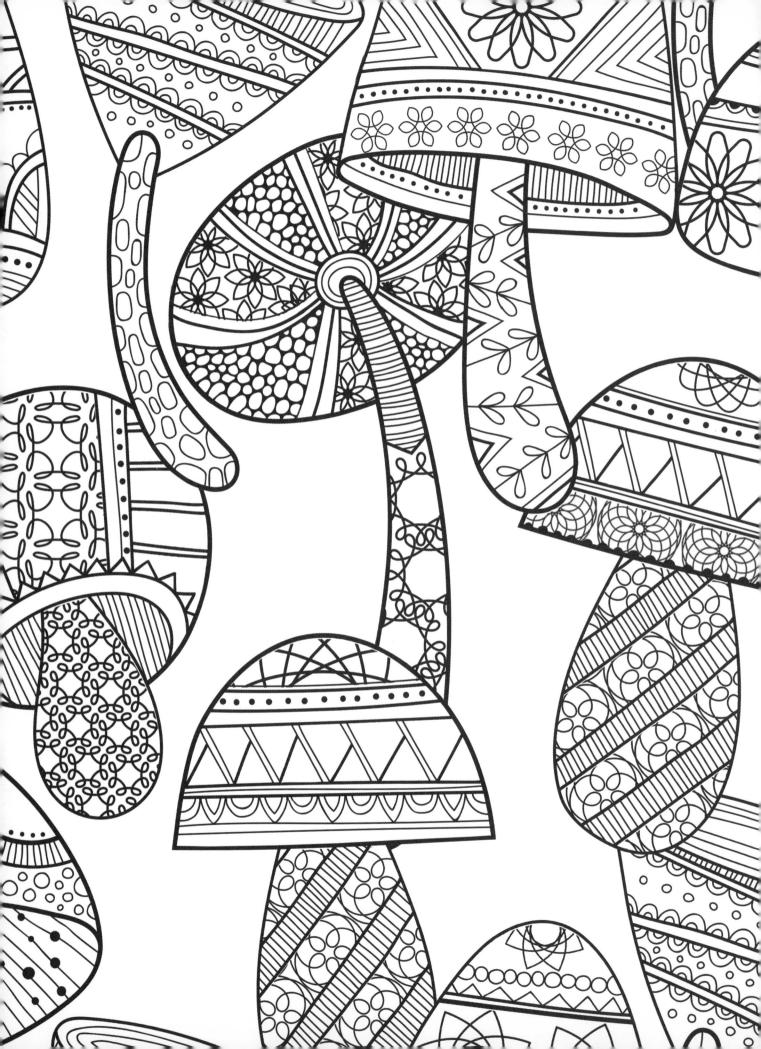

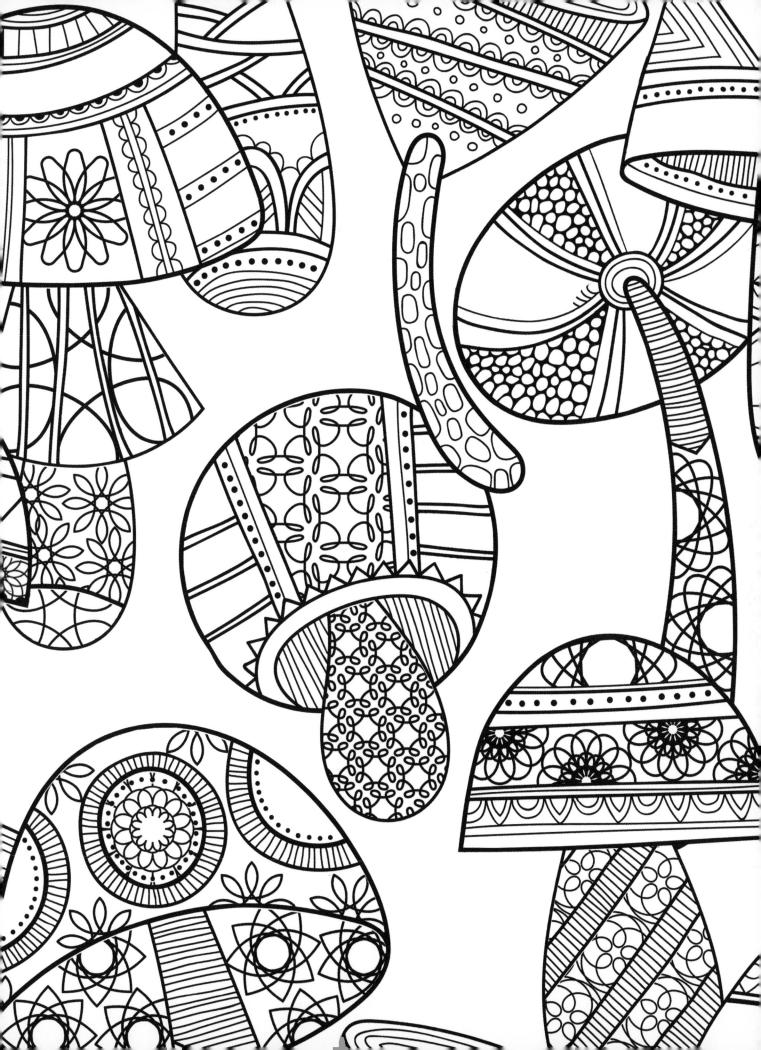

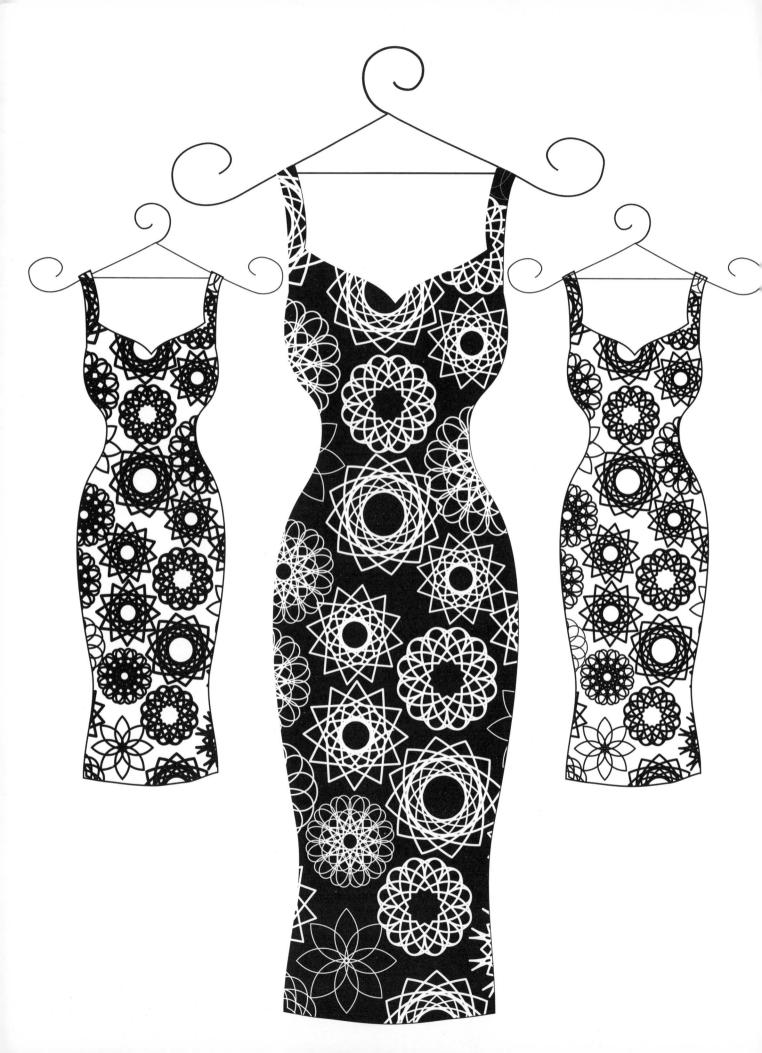

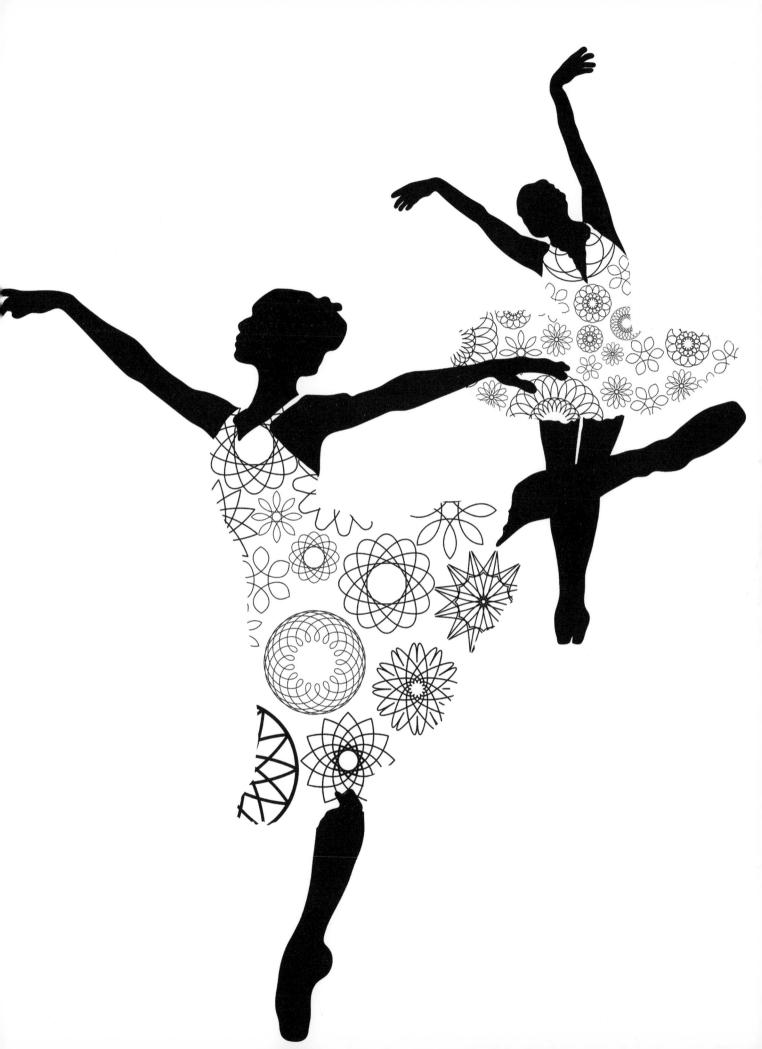

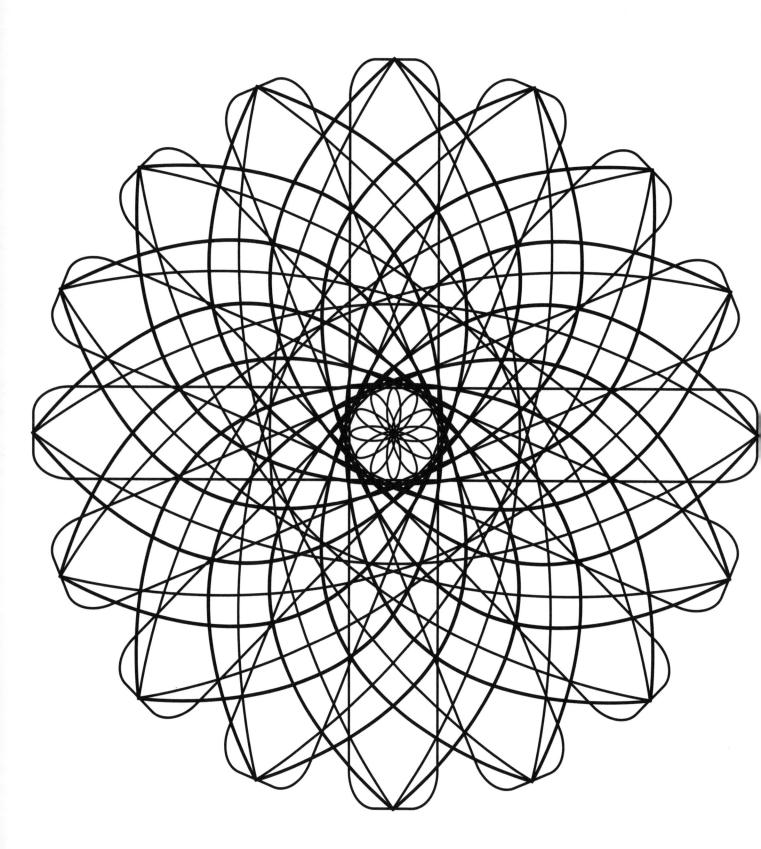

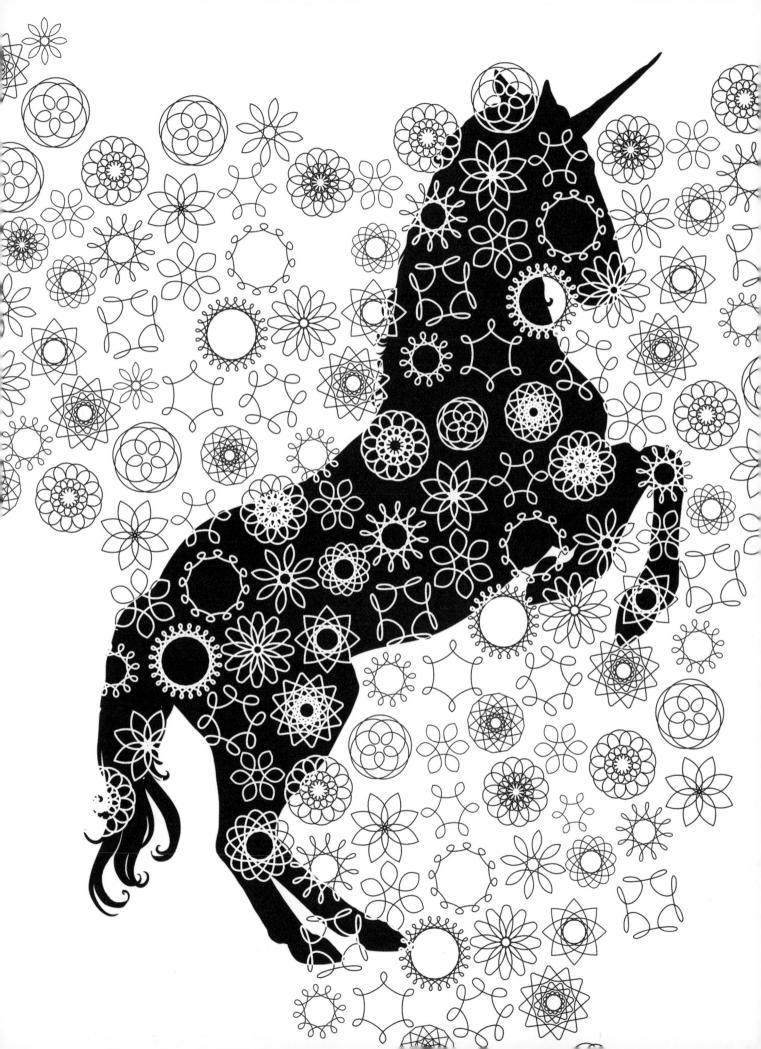

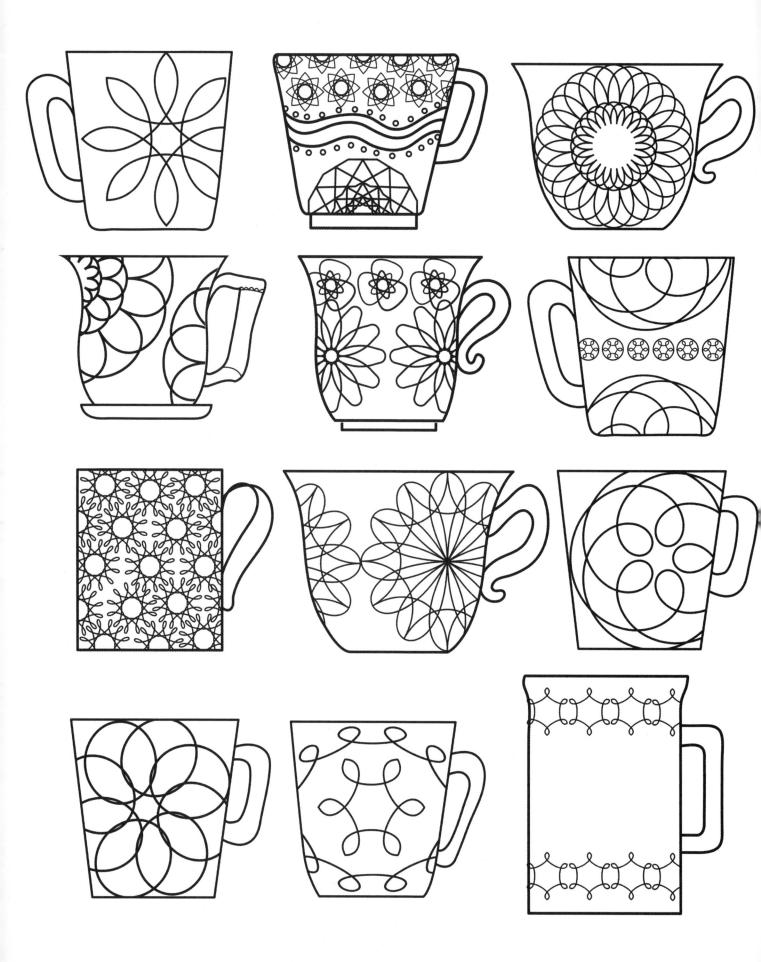

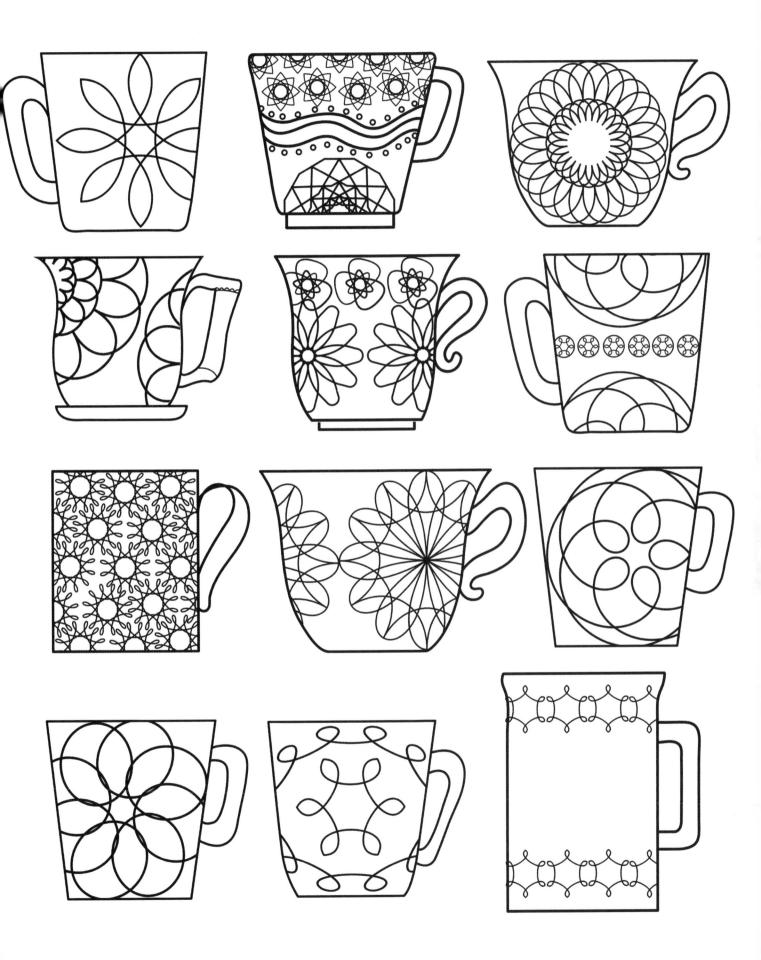

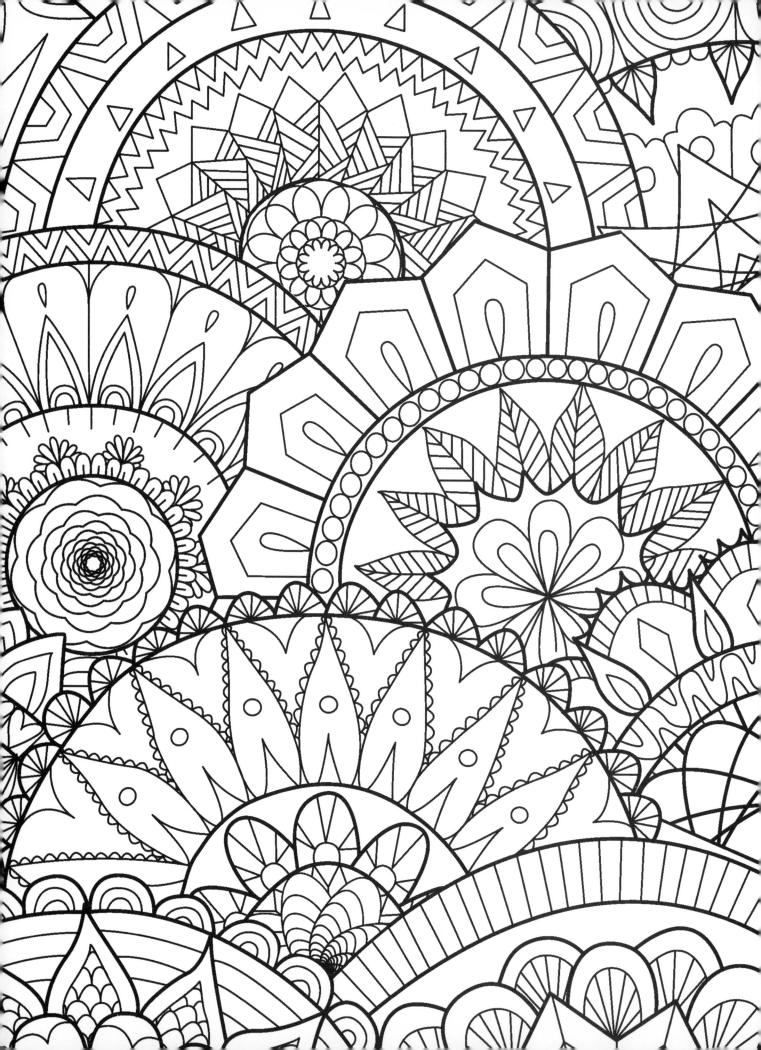

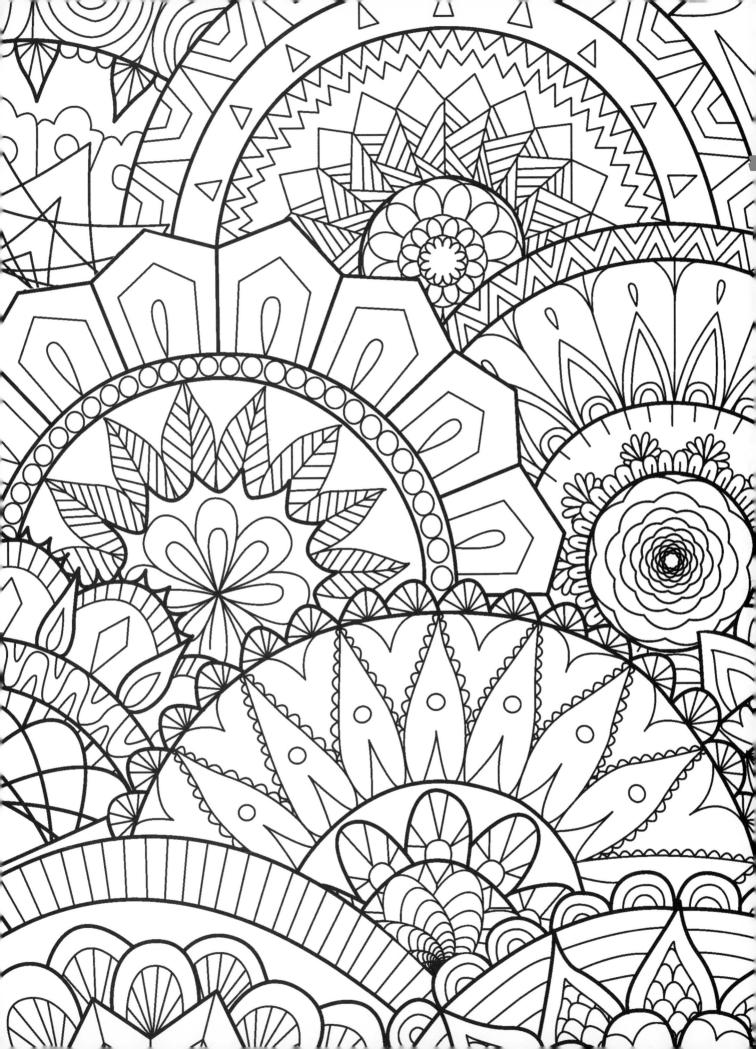

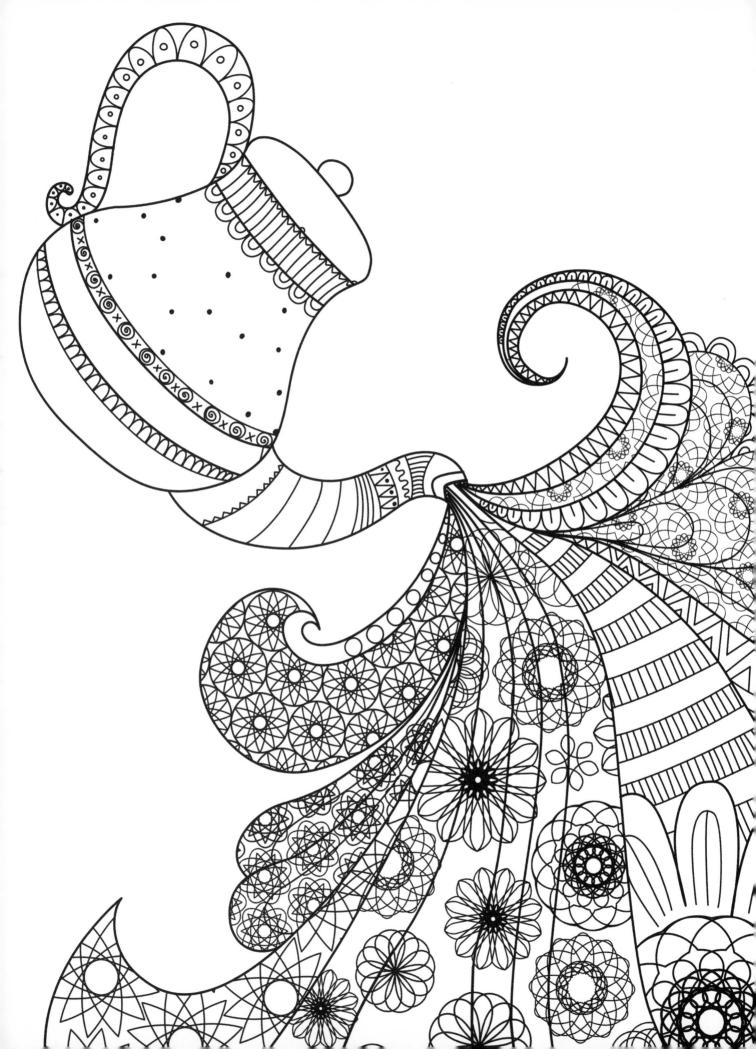

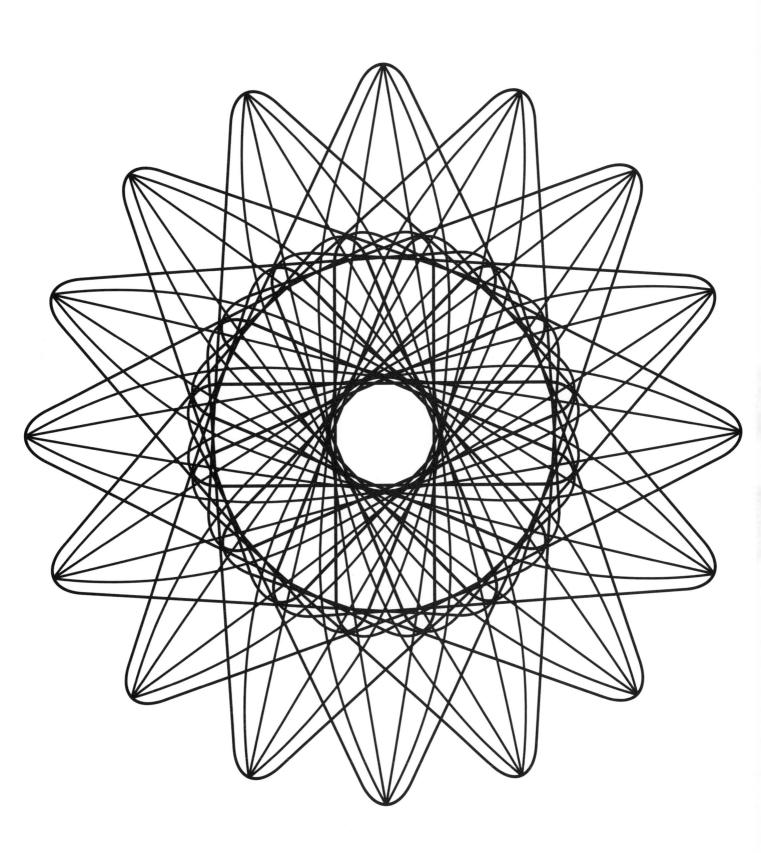

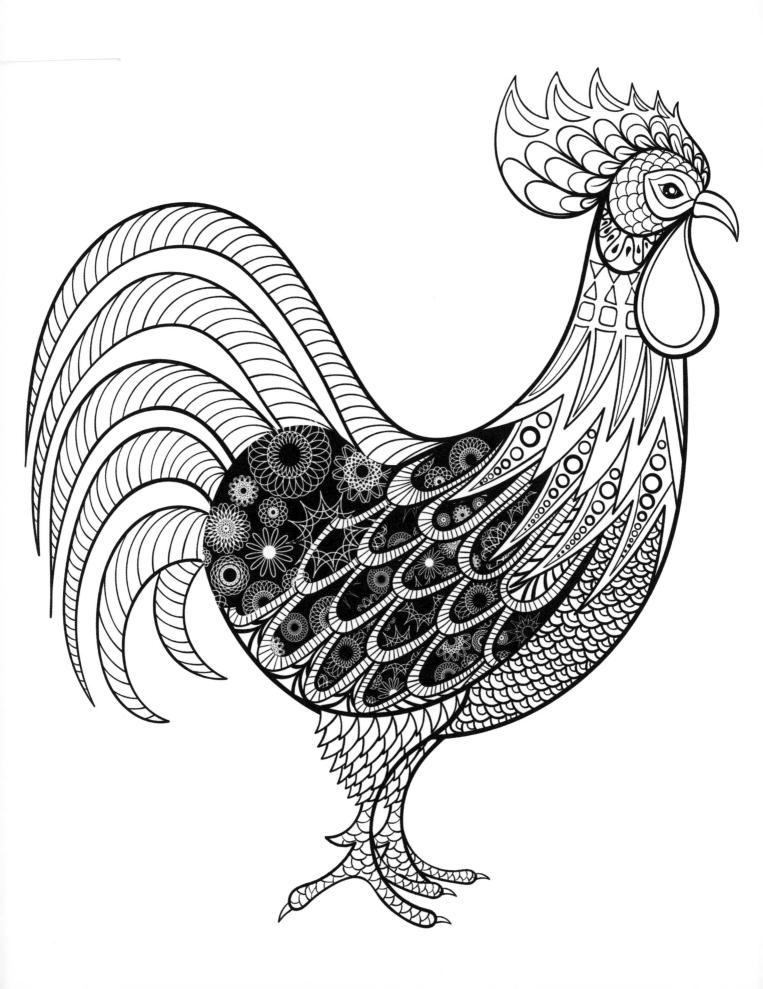

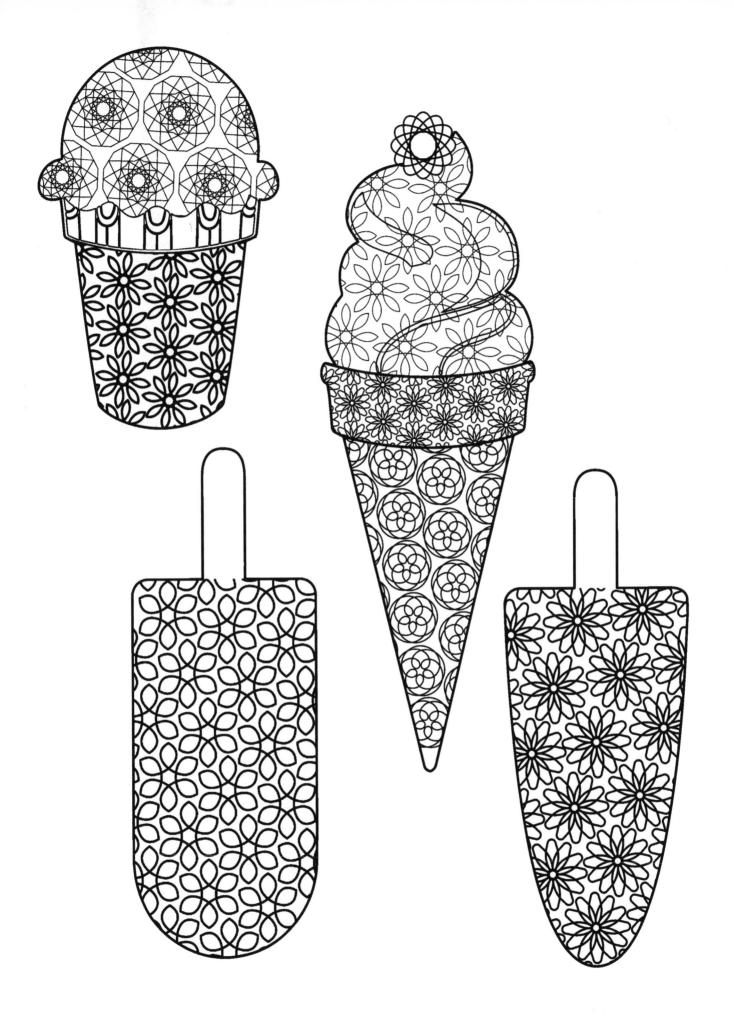

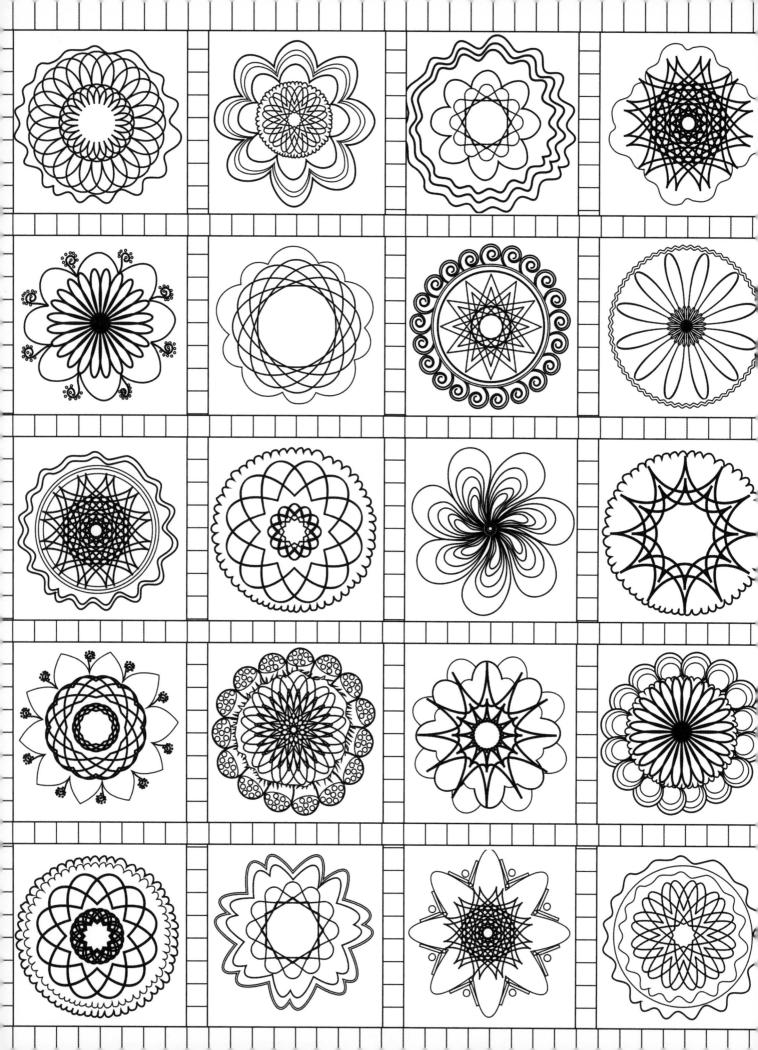

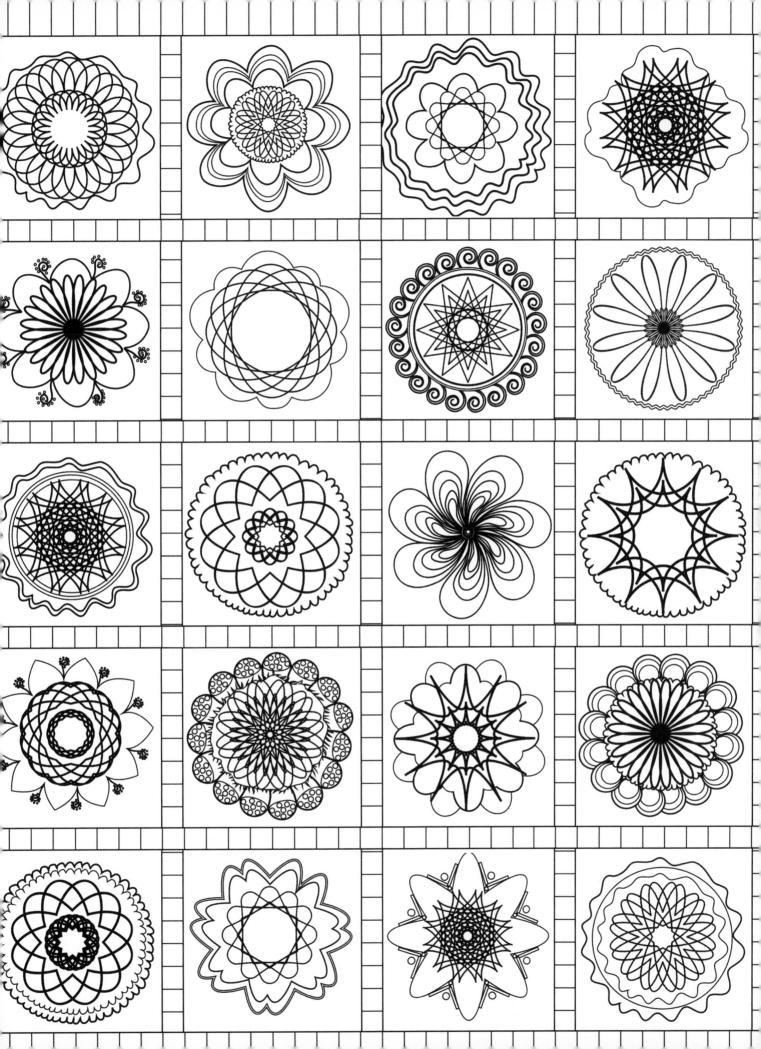

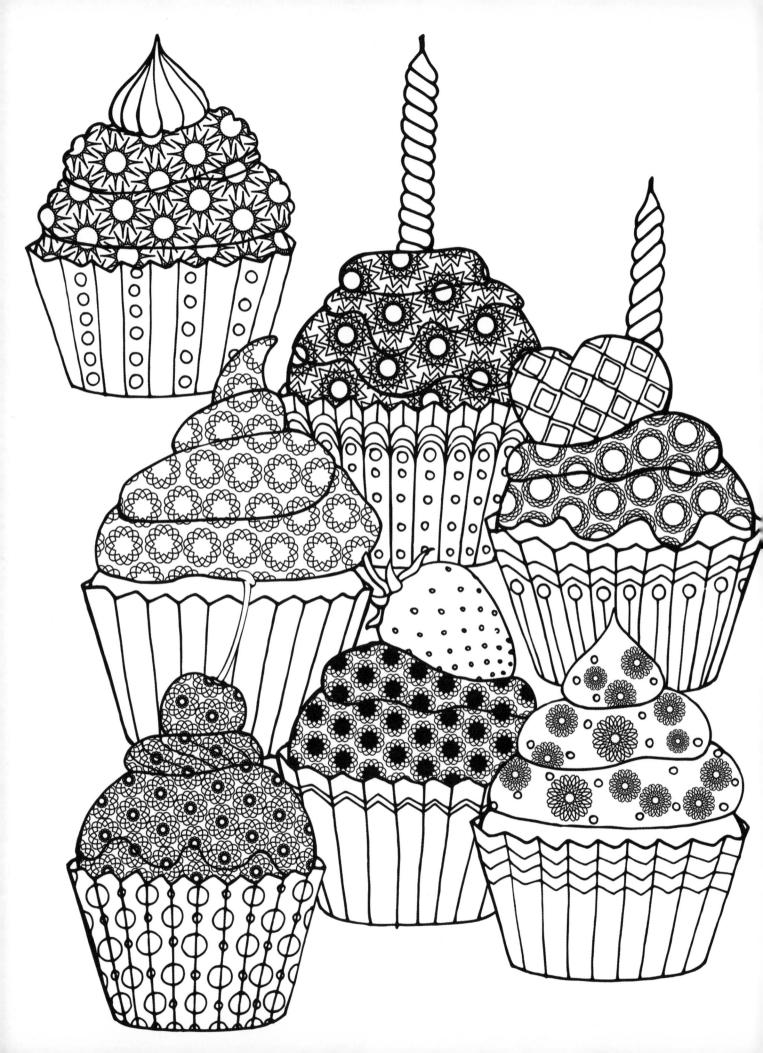

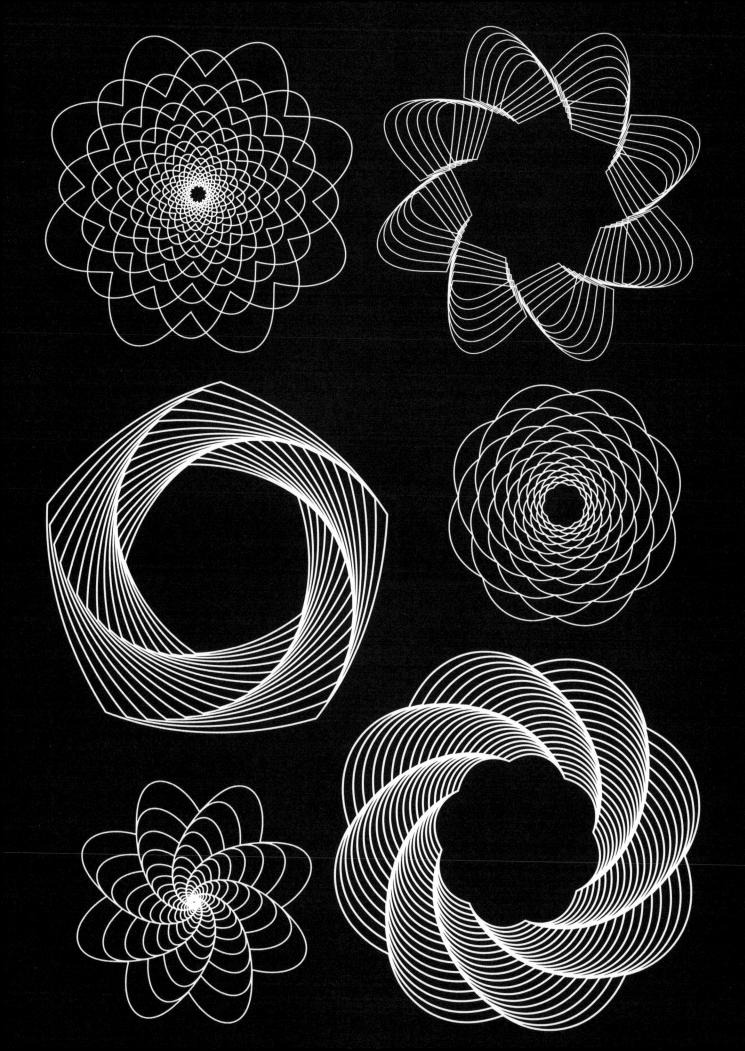

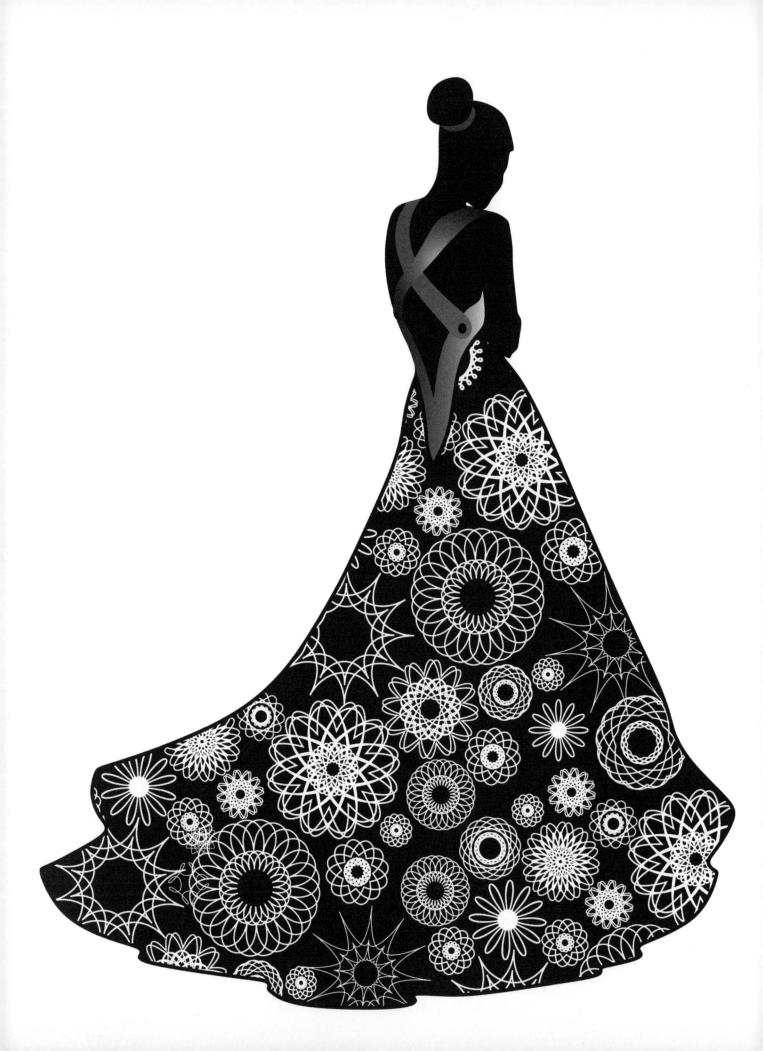

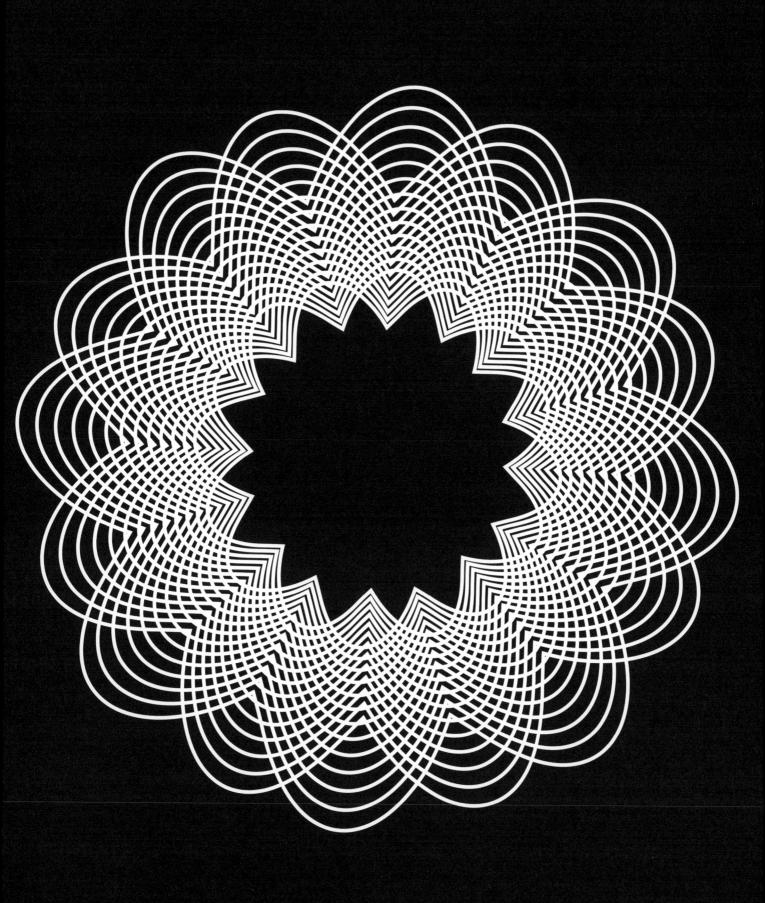

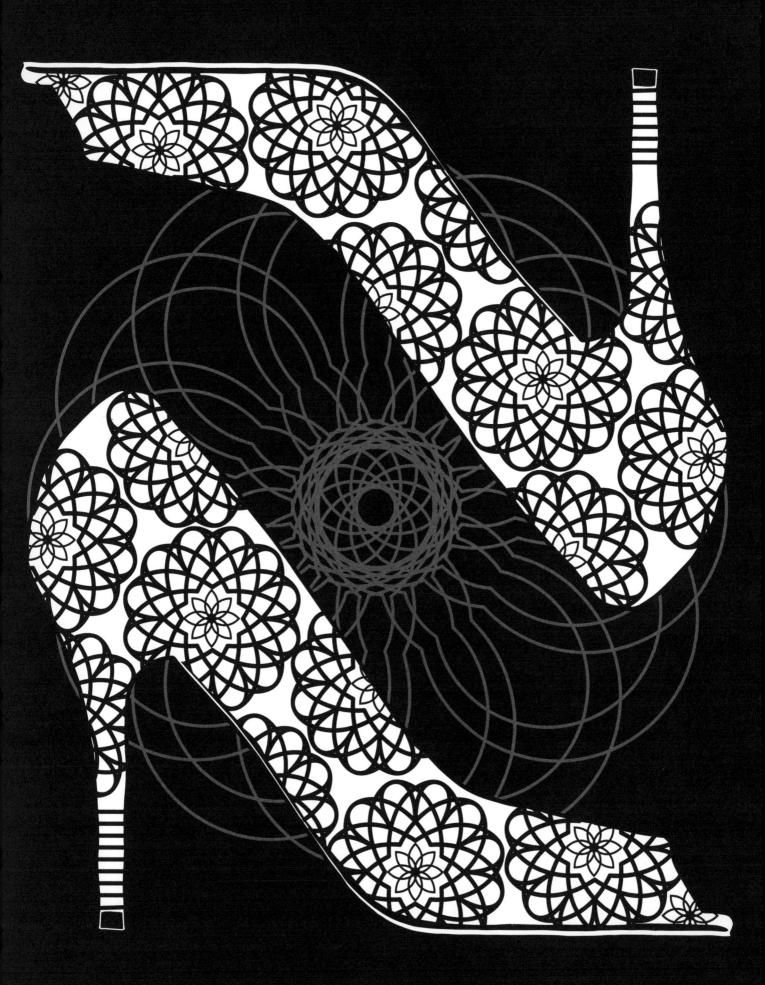

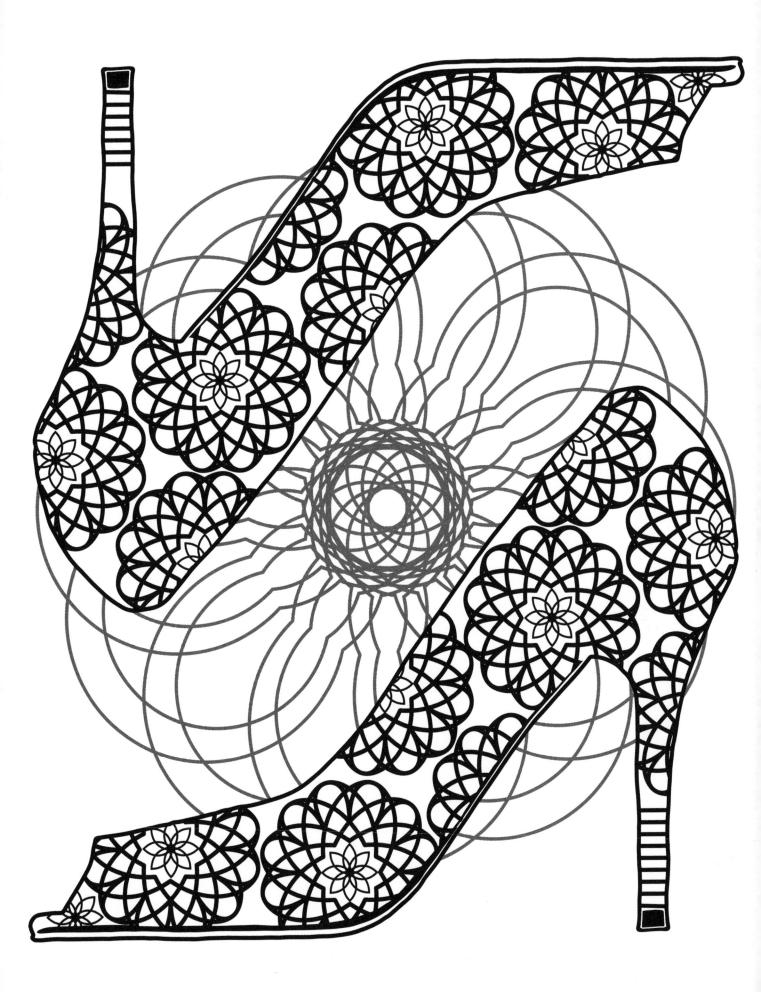

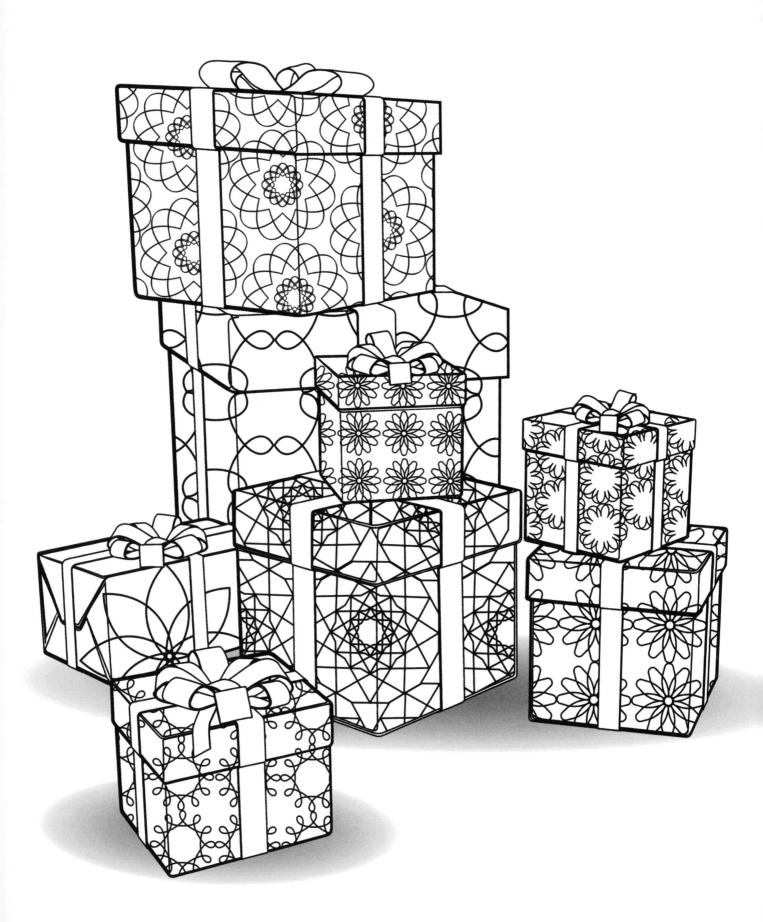

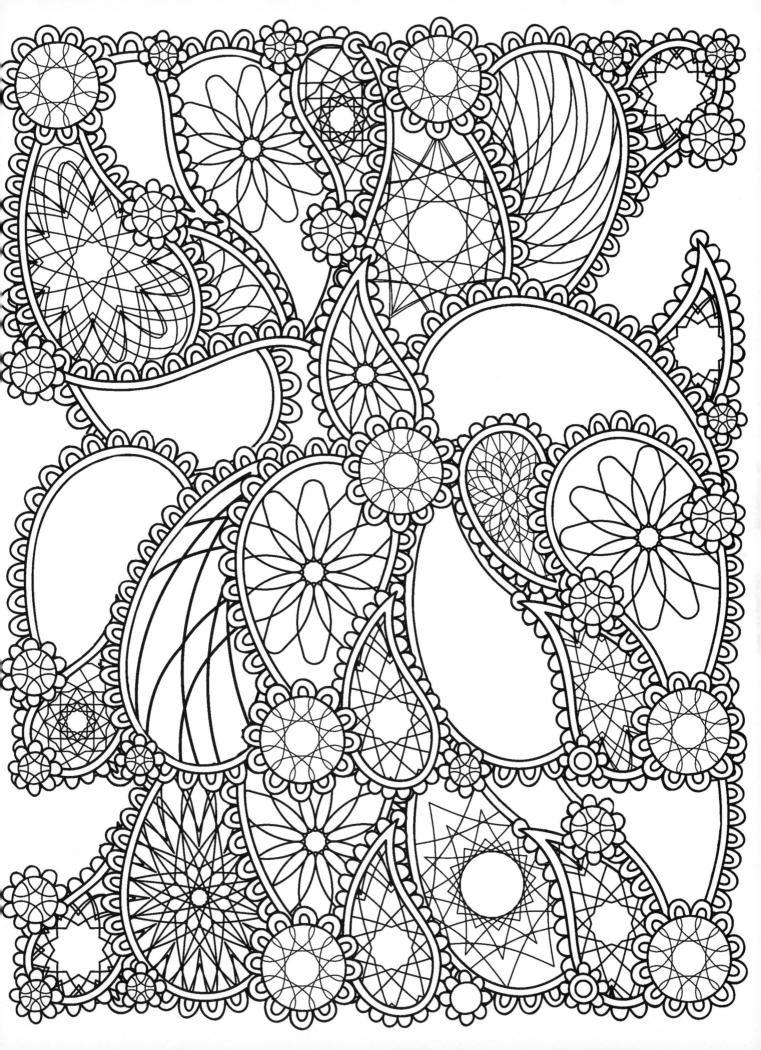

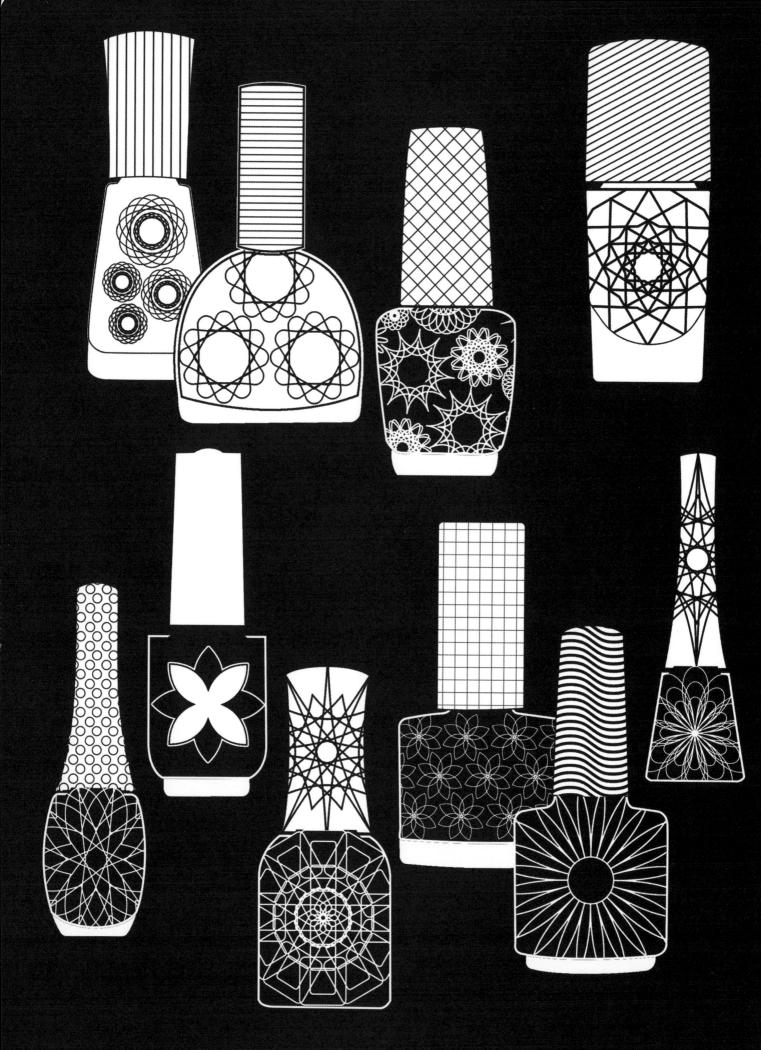

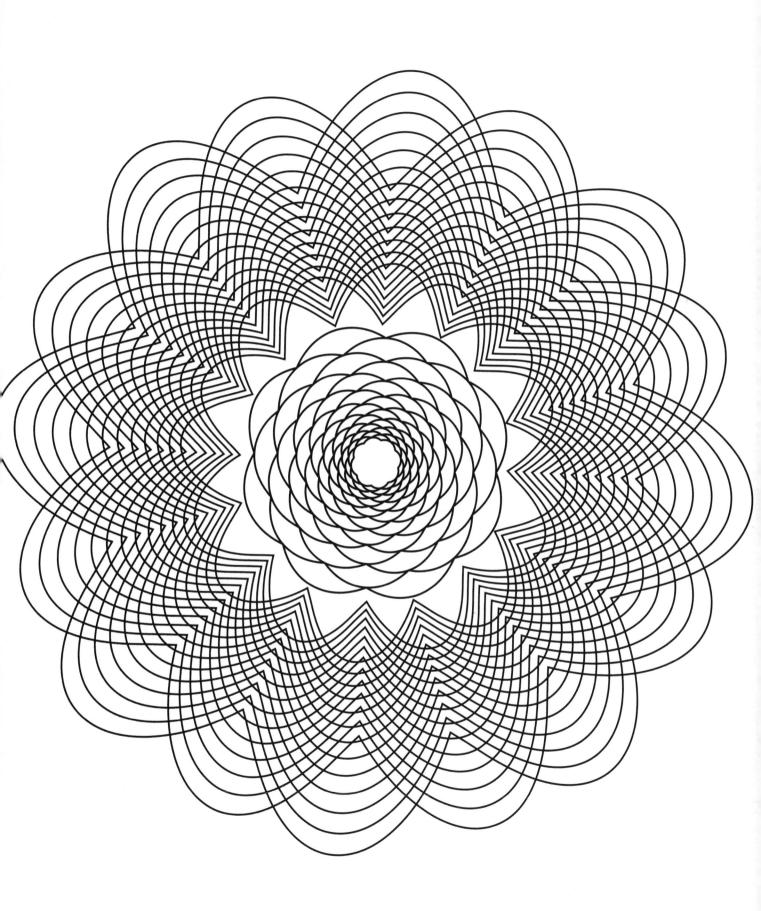

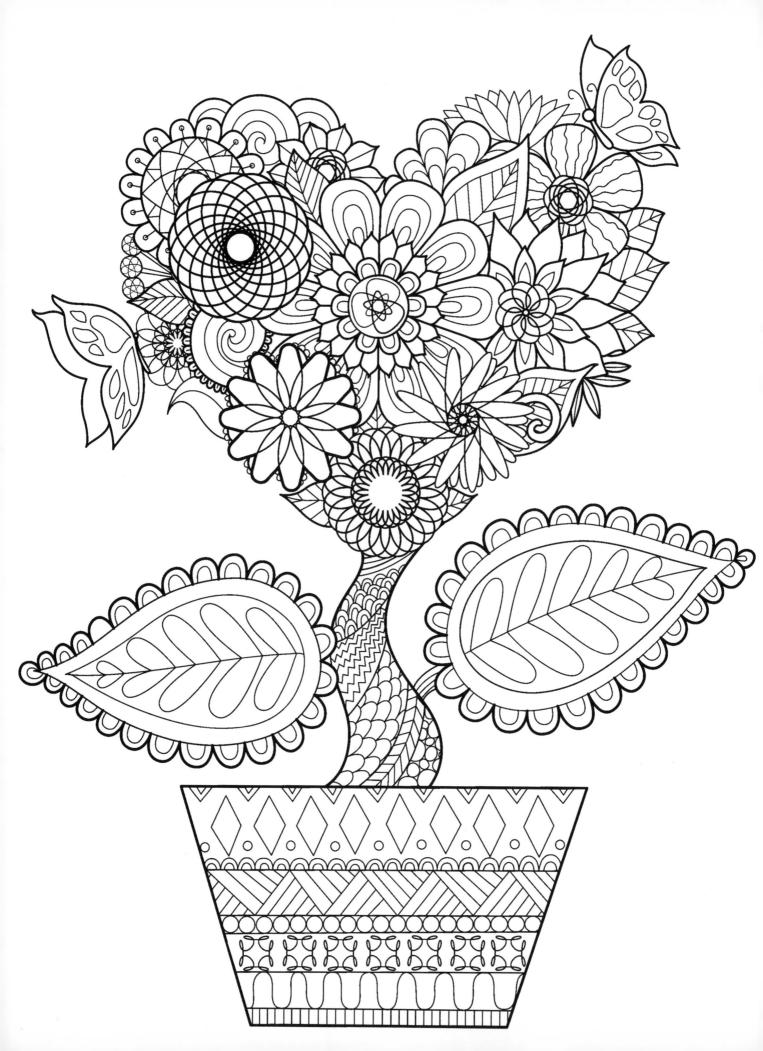

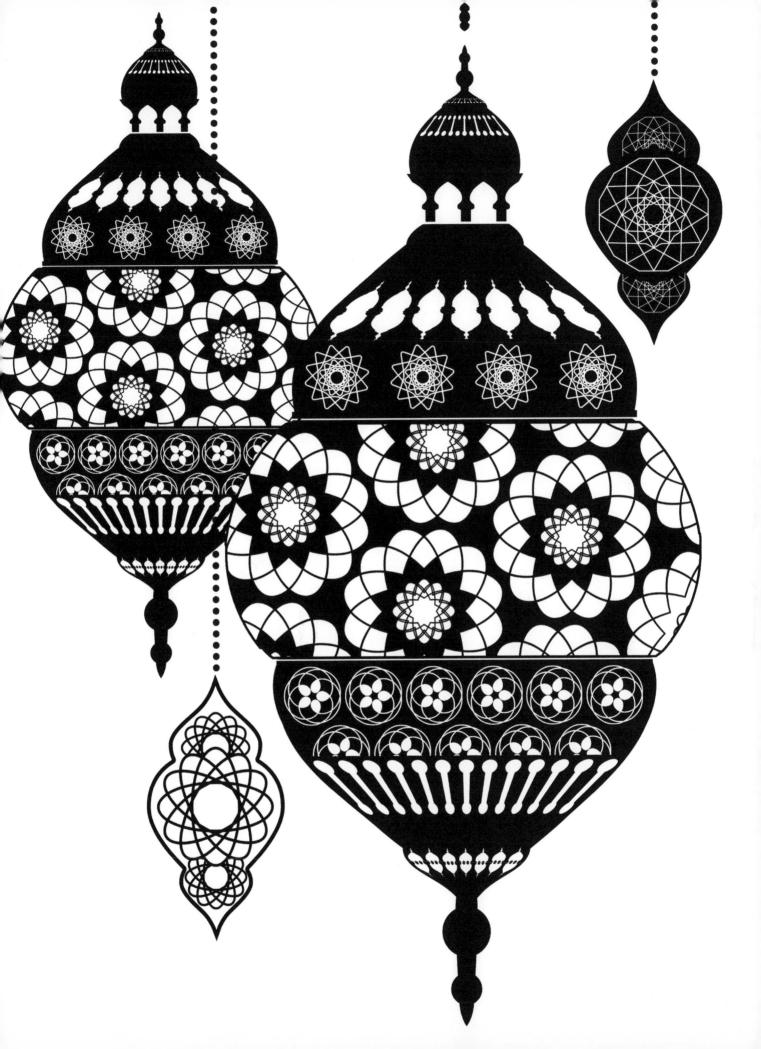

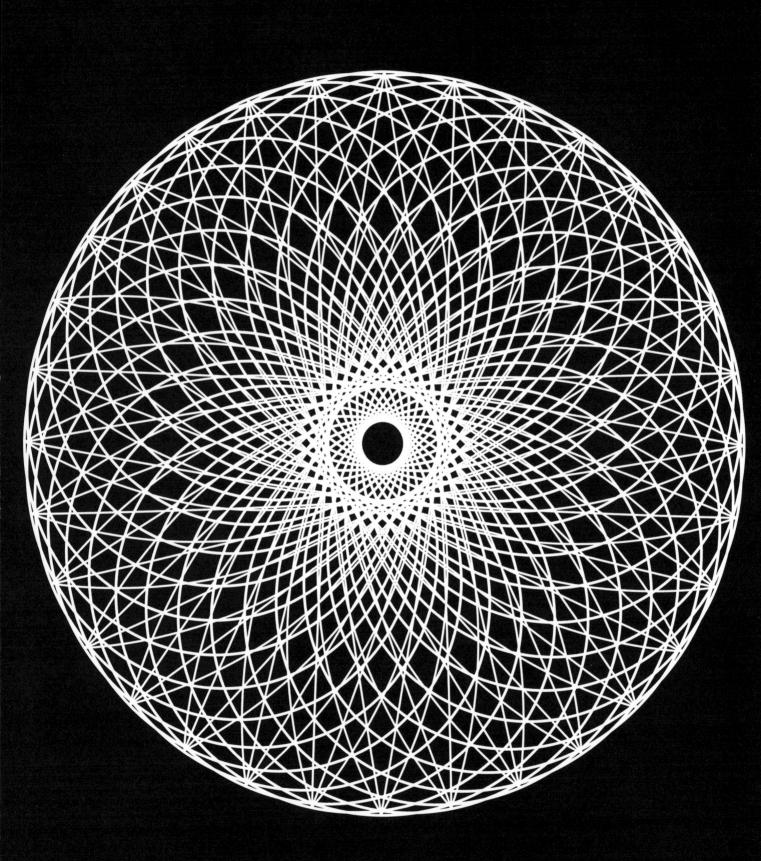

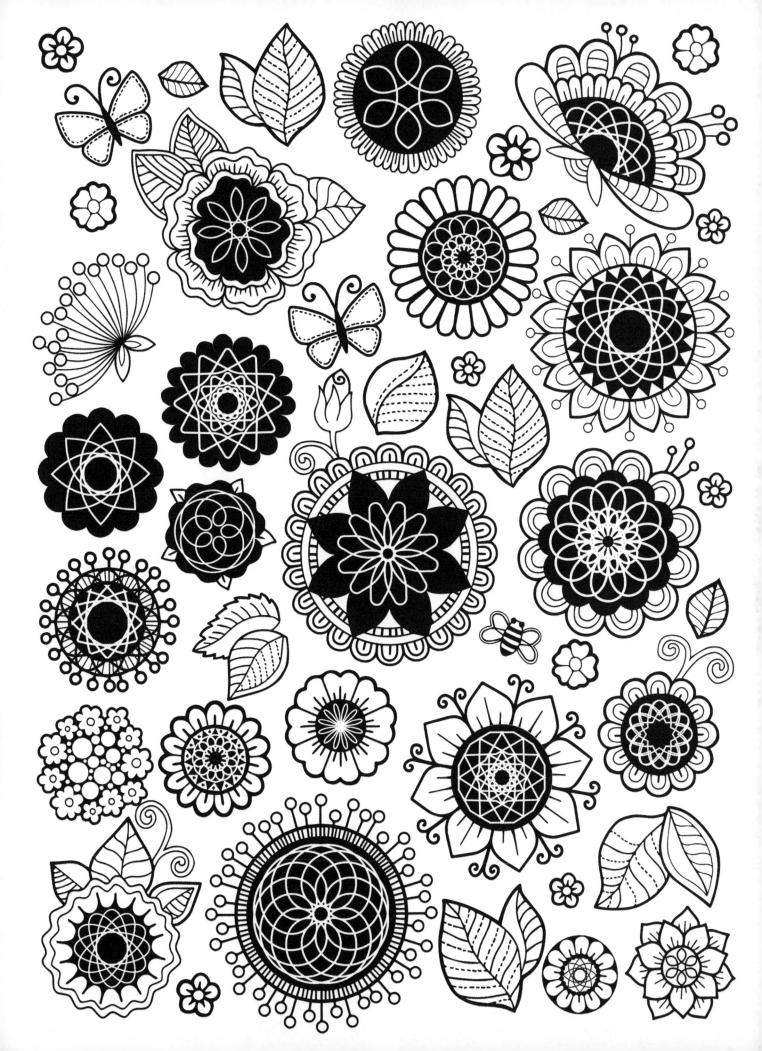

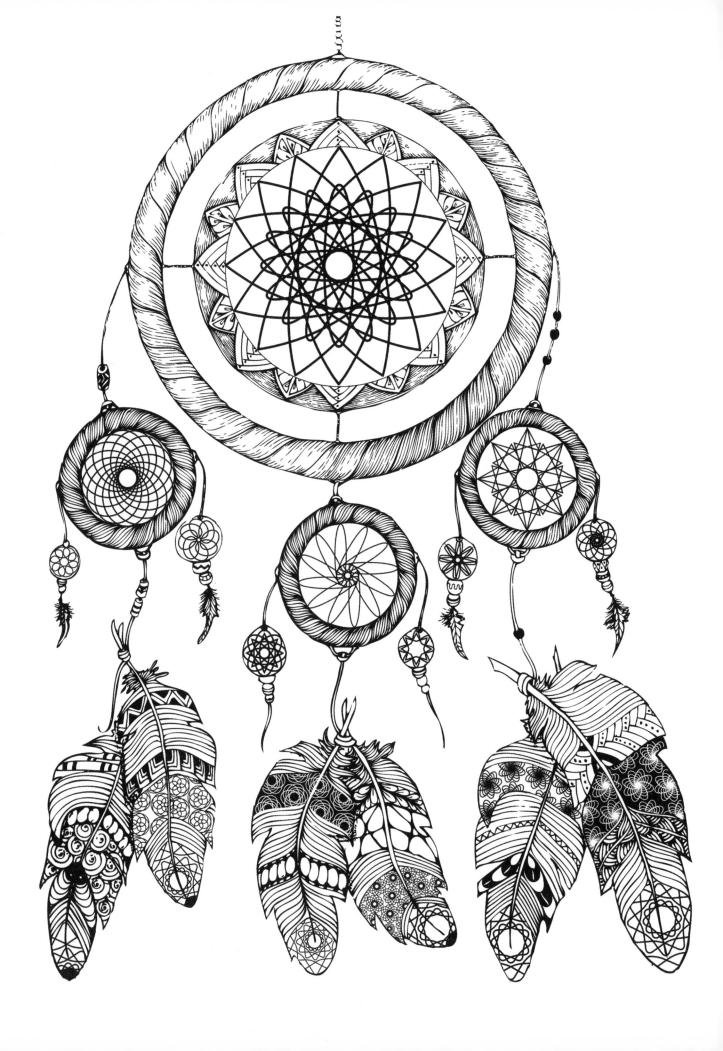

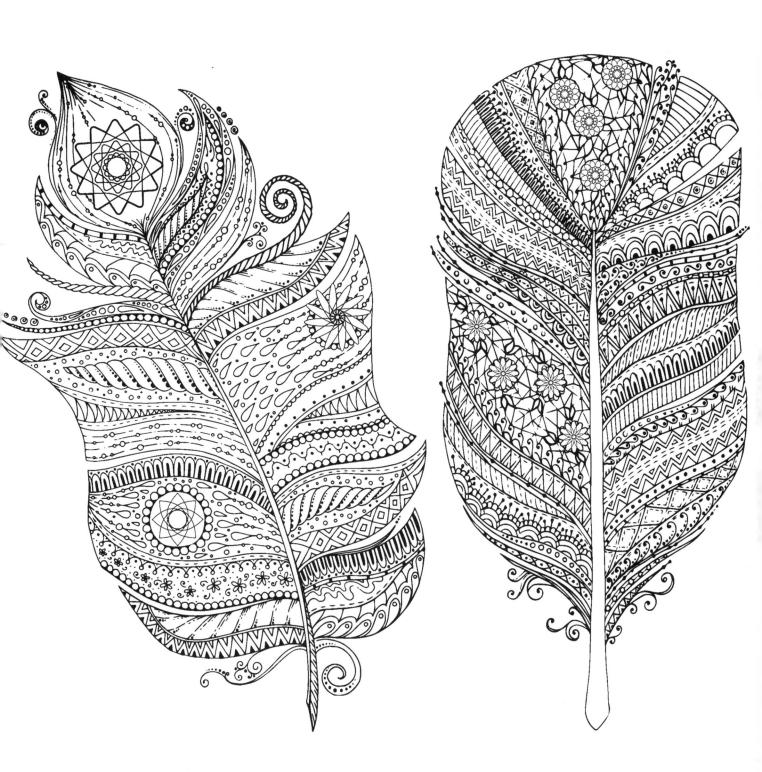

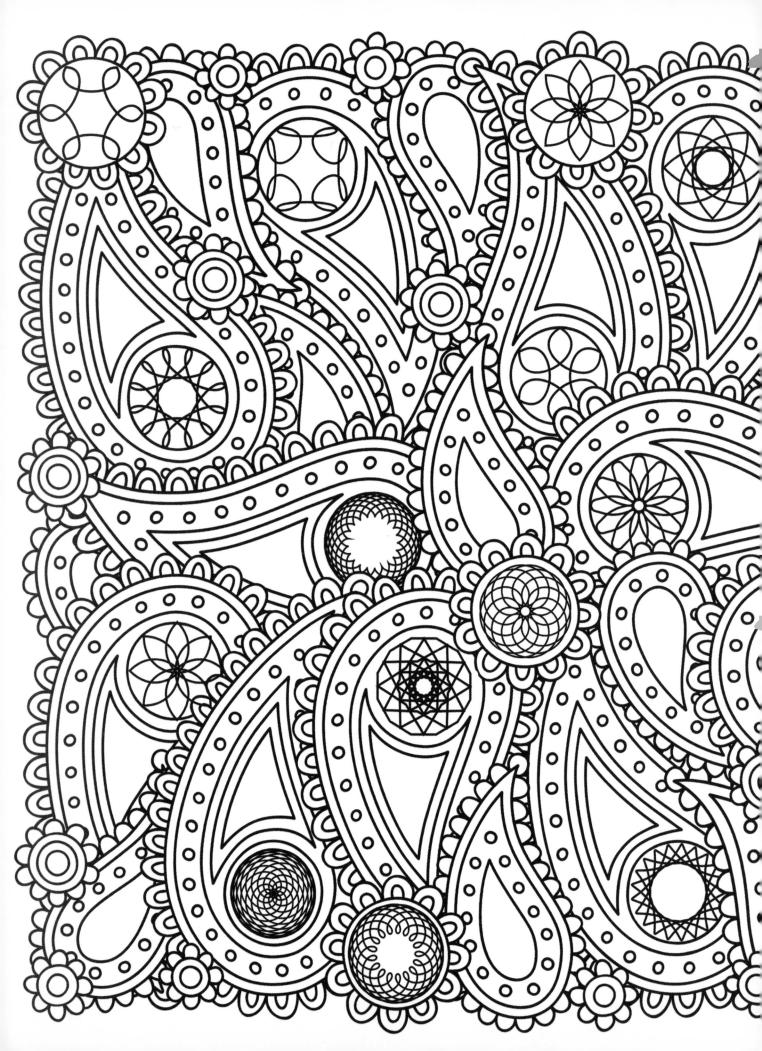

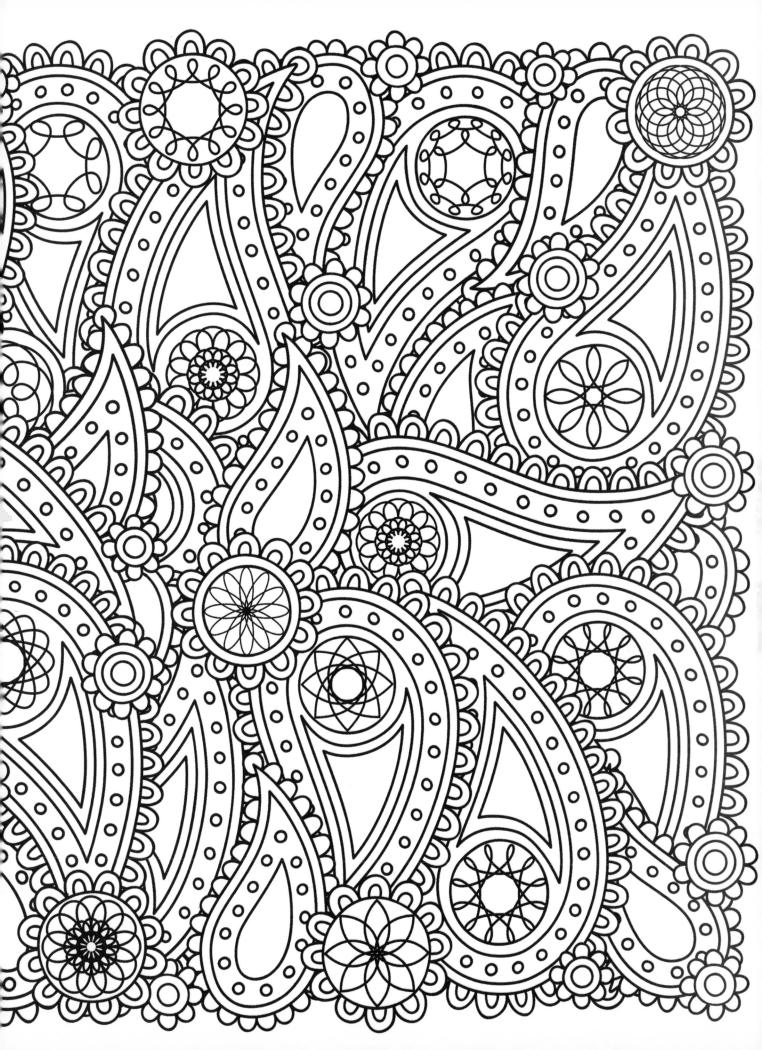

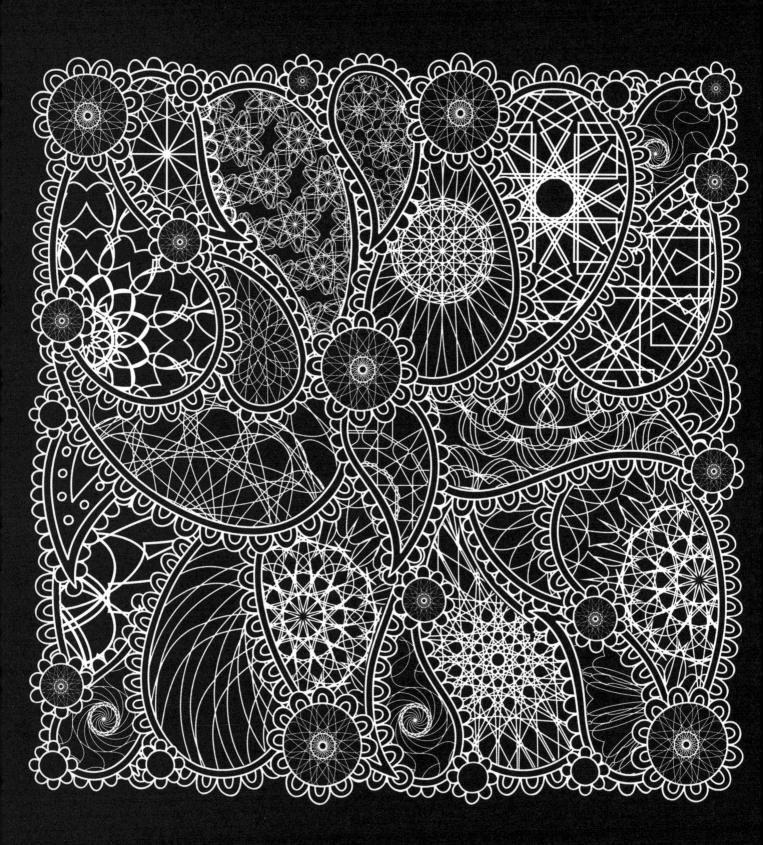

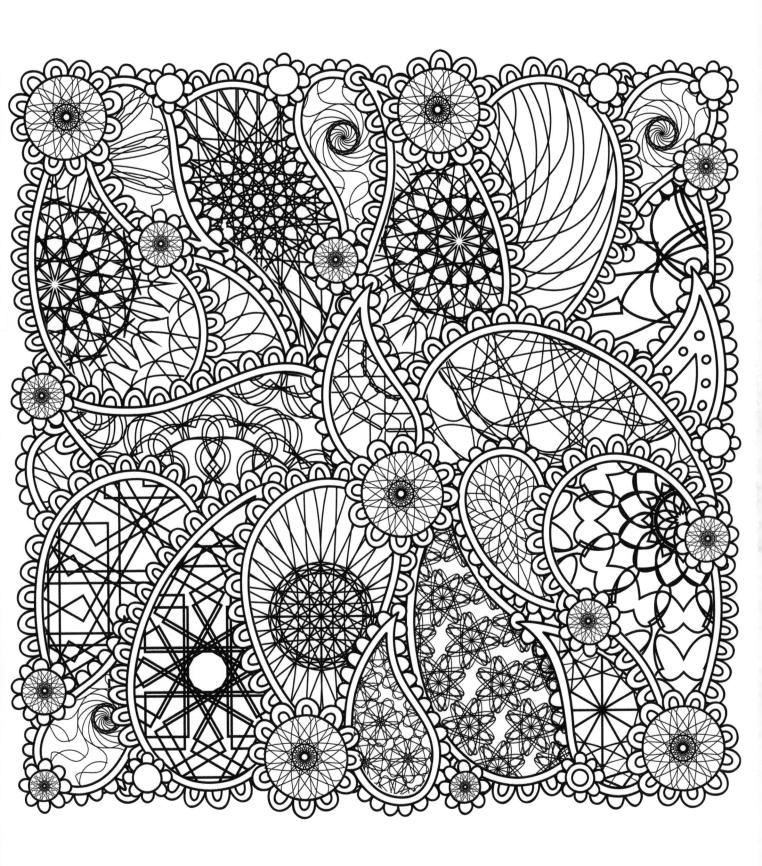

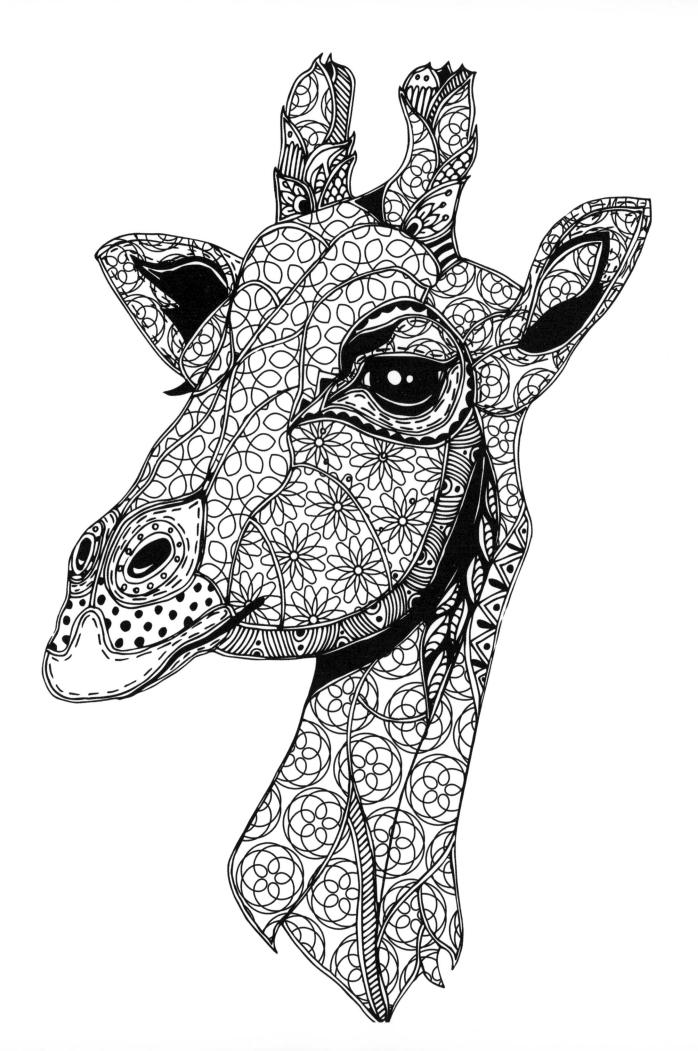

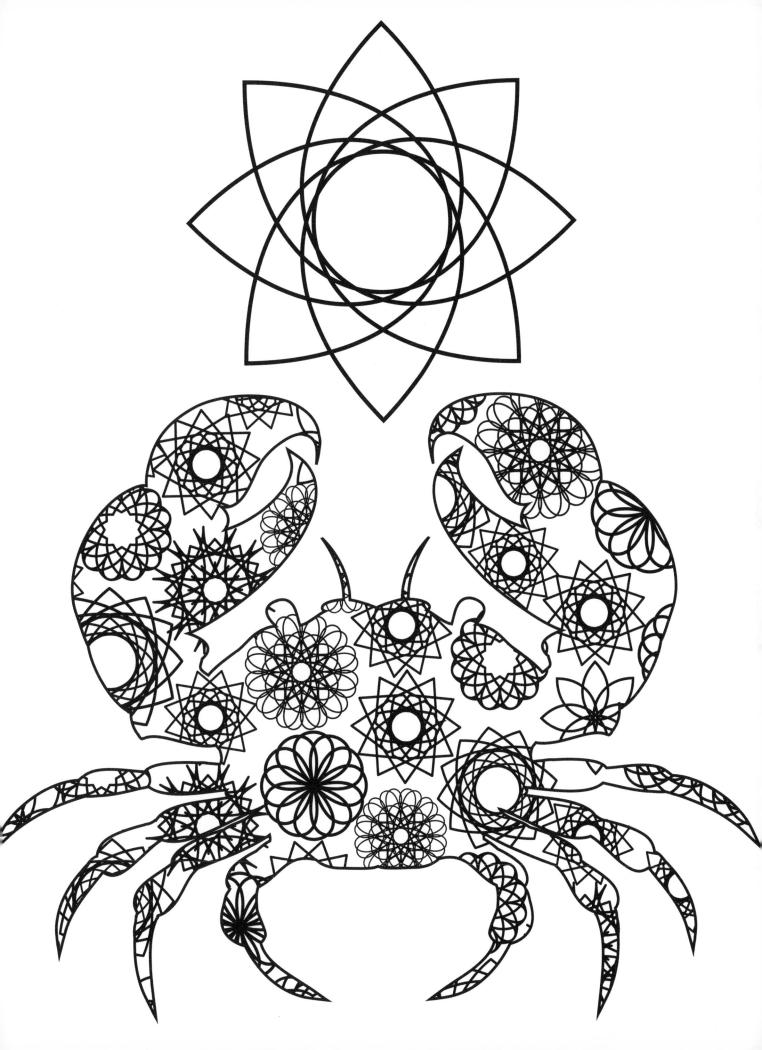

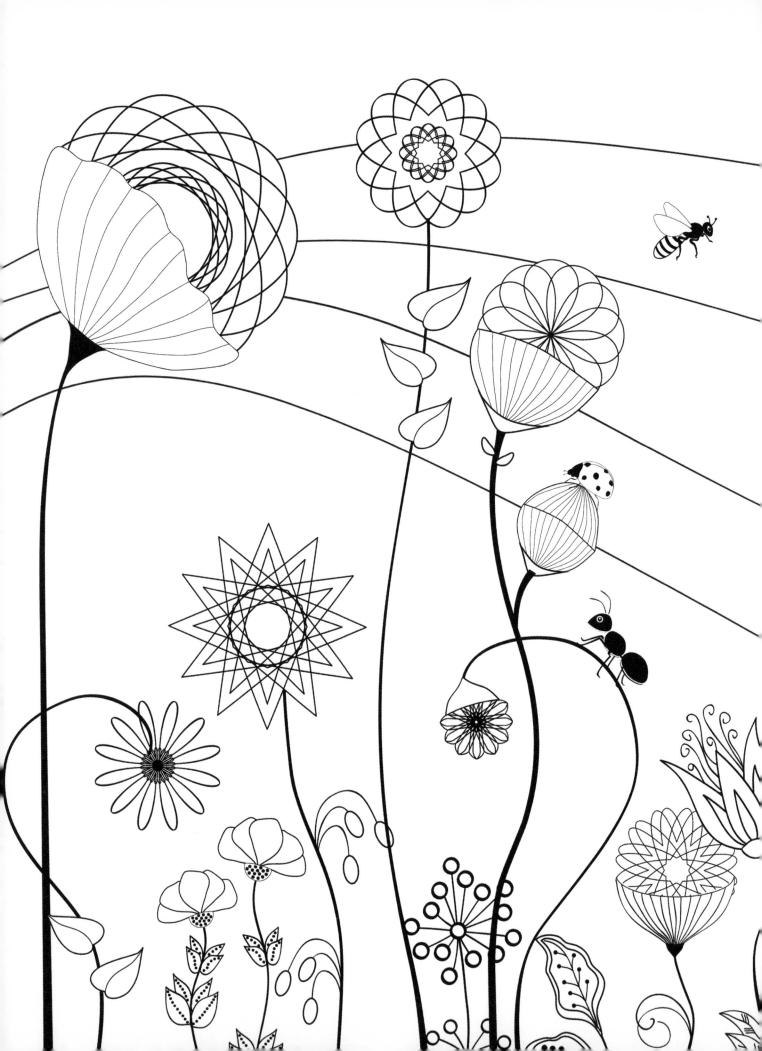

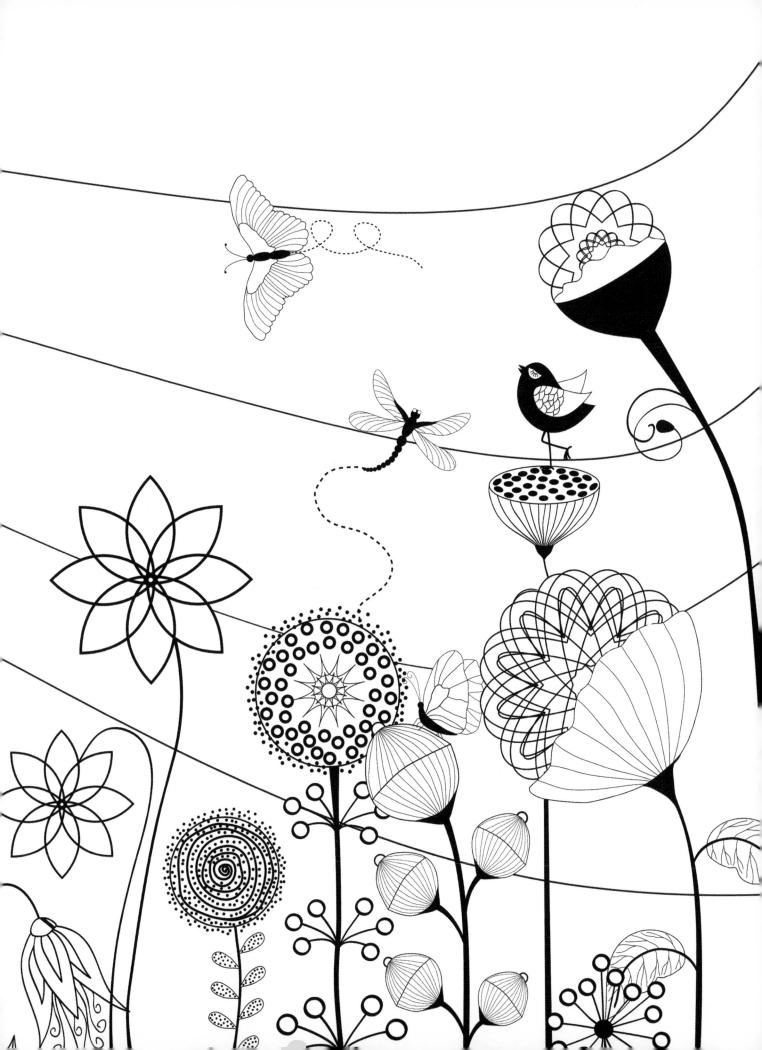

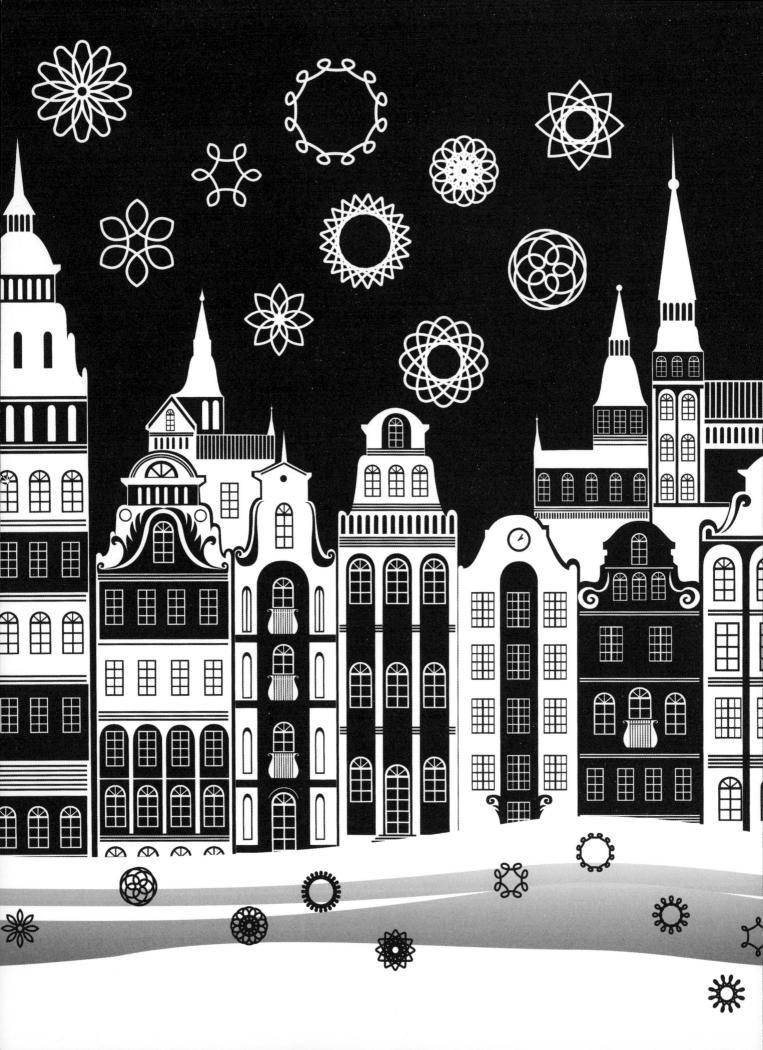

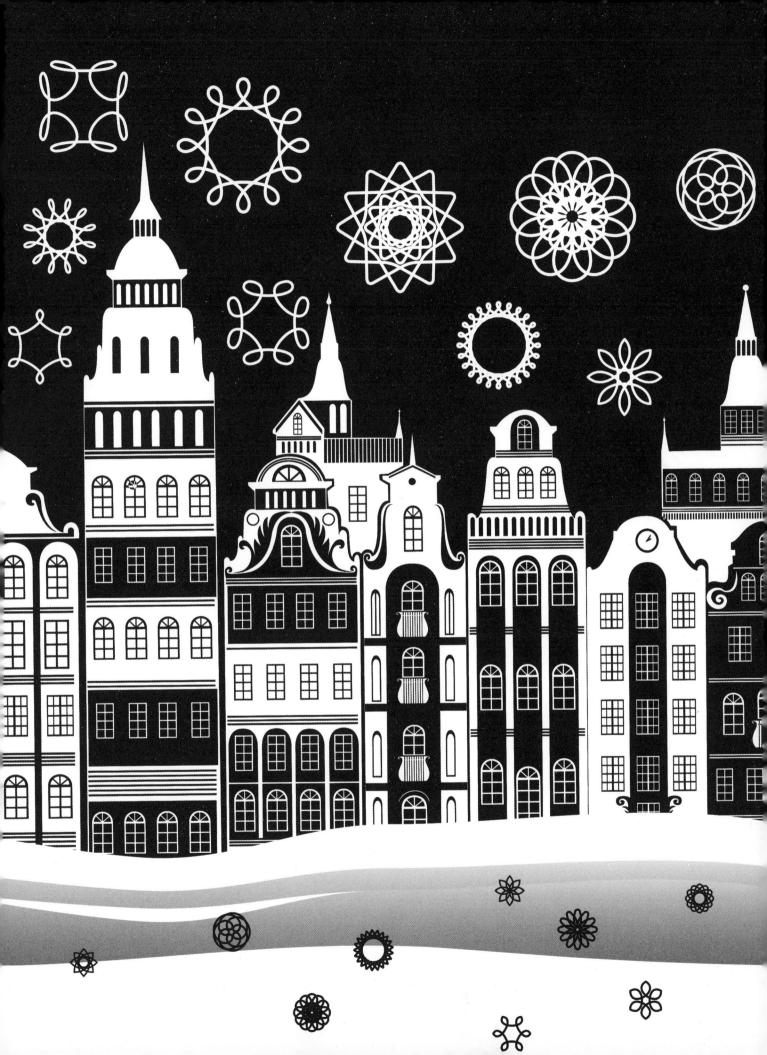

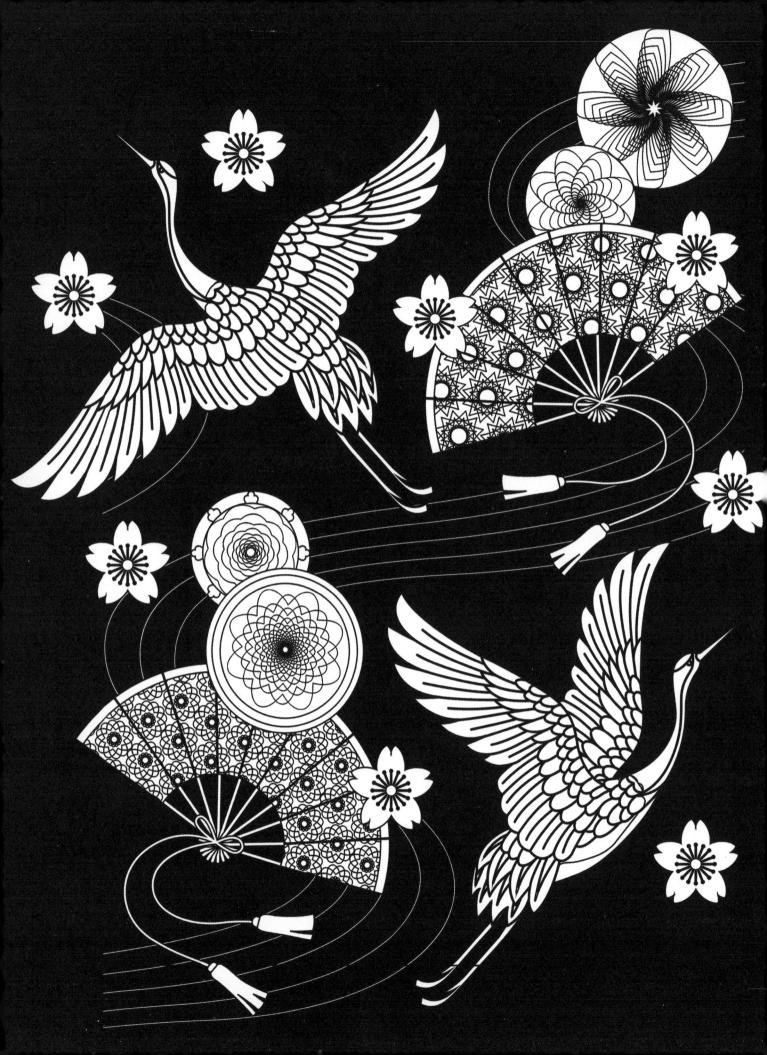